HIGH SOCIETY

THE LIFE AND ART
OF SIR FRANCIS GRANT
1803–1878

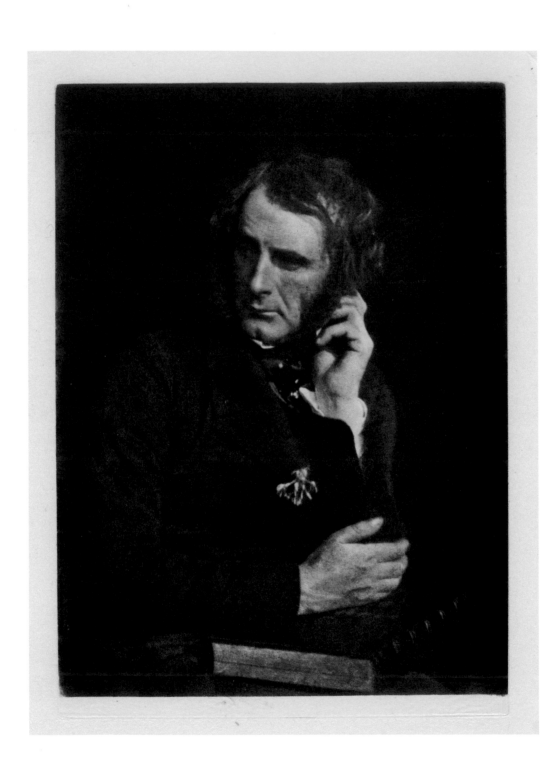

High Society

THE LIFE AND ART
OF SIR FRANCIS GRANT
1803–1878

Catherine Wills

National Galleries of Scotland
Edinburgh 2003

Published by the Trustees of the
National Galleries of Scotland to accompany
the exhibition *High Society: the Life and Art
of Sir Francis Grant 1803–1878* held at the
Scottish National Portrait Gallery, Edinburgh
from 19 June to 14 September 2003

© Trustees of the National Galleries of Scotland 2003
ISBN 1 903278 39 2

Designed by Dalrymple
Typeset in Adobe Utopia by Brian Young
Printed by Snoeck-Ducaju & Zoon, Belgium

Front cover: detail from *Mrs Markham* (cat.no.14)
Back cover: *Mrs Markham* (cat.no.14)

Frontispiece: J. Craig Annan after D. O. Hill
and Robert Adamson *Sir Francis Grant*.
Photogravure, *c*.1912, after the original
calotype taken 12 September 1845
Scottish National Photography Collection
at the Scottish National Portrait Gallery

CONTENTS

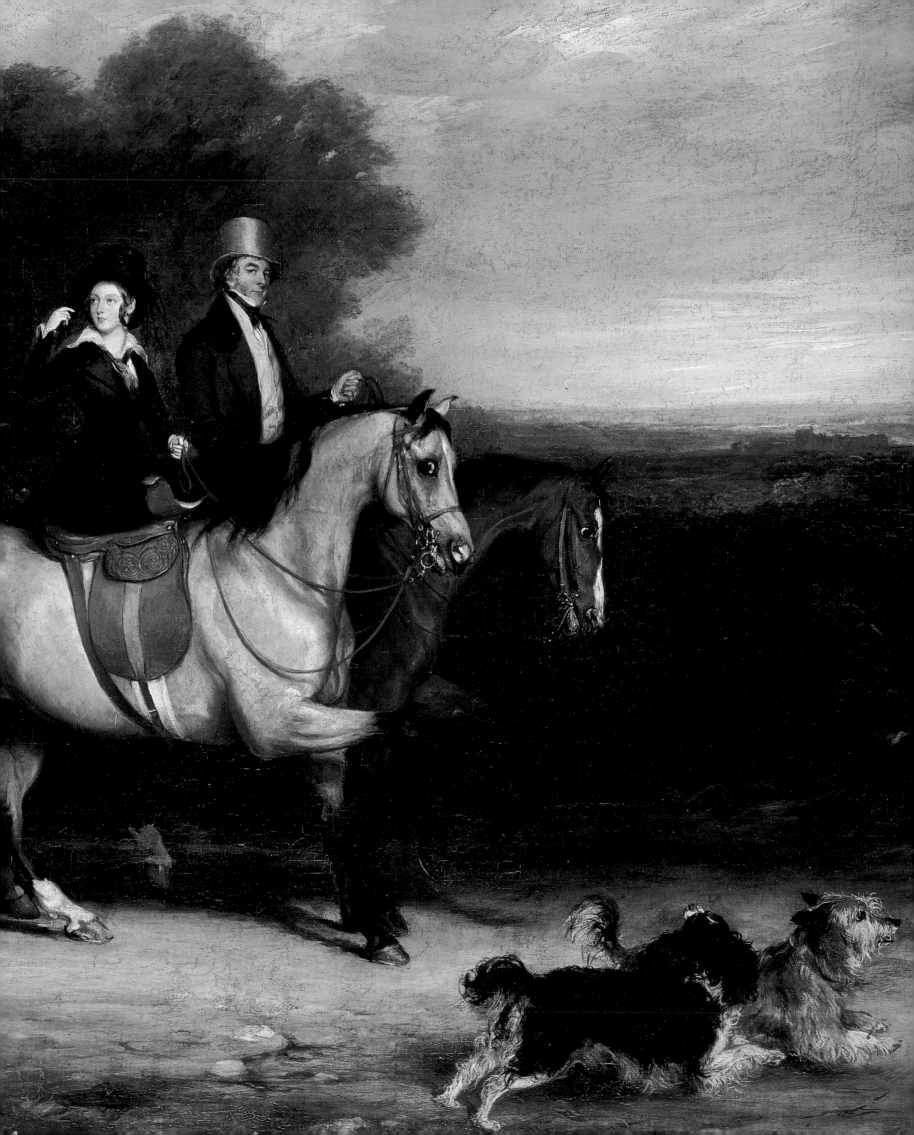

FOREWORD

That the most brilliant contemporary reputation can be dimmed to obscurity by the passage of time is all too clearly demonstrated by the fact that there has never been an exhibition devoted to the work of the artist, Sir Francis Grant PRA (1803–1878). Grant, the younger son of a Perthshire laird, was the only Scottish president of the Royal Academy in London and a dominant player in the Victorian art world. He was one of the most sought after portrait painters of his day, chosen by leading aristocrats, celebrated beauties, politicians and entrepreneurs to present their likenesses to posterity. It was said, by one of Grant's obituarists, that the world captured by these depictions would 'almost serve the purpose of a National Portrait Gallery'. It is, therefore, most appropriate that the two hundredth anniversary of the birth of this fascinating, but largely forgotten, figure is celebrated by a comprehensive survey of his life and work at the Scottish National Portrait Gallery.

We are most grateful to Dr Catherine Wills who has curated the exhibition and written the accompanying catalogue. Her unrivalled knowledge of Grant and her infectious enthusiasm for Grant's qualities as a painter and as a person have been instrumental at every stage of this project. Her selection from Grant's oeuvre reveals him as both a natural painter (initially a self-taught amateur, his decision to become a professional artist led Queen Victoria to observe that Grant 'was a gentleman' but 'now paints for money') and a thoughtful assimilator of the achievements of fellow artists, past and present. In a career spanning five decades, a remarkable range of achievement and a surprising capacity for development is laid before us. We hope that visitors will be surprised, delighted and impressed by what they see, and that Grant may once again enjoy the acclaim he enjoyed during his lifetime from critics as discerning as Delacroix and Baudelaire.

Exhibitions are complex, collaborative ventures and within the National Galleries of Scotland many staff have given time and expertise to this project. We would particularly like to thank Nicola Kalinsky who has worked closely with Catherine Wills on all aspects of the exhibition. She, in turn, would like to acknowledge the support from her colleagues in the National Galleries: in particular, Janis Adams, Robin Baillie, Alison Boocock, Harriet Johnson, Lesley Stevenson and Agnes Valencak-Kruger. Thanks are also due to Dr Duncan Thomson and Edward Longbottom.

The National Galleries of Scotland would like to thank Her Majesty The Queen for lending *Queen Victoria Riding Out*, the work which established Grant's standing as the leading portrait painter of the day. We also acknowledge with gratitude the contribution made by all our lenders, public and private; in particular, the owners of *Mrs Markham*, without whose exceptional generosity we would not have been able to show this most appealing of pictures. A special debt is owed to the Paul Mellon Centre for Studies in British Art whose decision to support this publication acted as a moral imprimatur as well as being of practical assistance. We also record with much gratitude our delight that Francis Finlay has supported this exhibition.

SIR TIMOTHY CLIFFORD
Director-General,
National Galleries of Scotland

JAMES HOLLOWAY
Director, Scottish National Portrait Gallery

AUTHOR'S PREFACE

The first art historian known to have been interested in Sir Francis Grant was the late John Steegman, who contemplated writing a Grant biography whilst Director of the National Portrait Gallery in London during the 1940s. On his departure to live in the United States of America, he left all his Grant papers to the National Portrait Gallery archives. These were an excellent starting point for my Ph.D. thesis on Grant written in the late 1970s and early 1980s. I owe John Steegman a great debt of gratitude and hope that he would have been pleased to see the first exhibition devoted to Francis Grant.

I am grateful to the many people who have helped with this exhibition, particularly Wendy Cooper, David Ker, Alastair Laing, Neil MacGregor, David Moore-Gwyn, Anthony Mould, Angela Nevill, Richard Ormond, Francis Russell, Helen Smailes, Nicolas White and Henry Wyndham.

I would like to thank all of the above, as well as the generous owners of the works included in the exhibition, and those who have allowed their paintings to be reproduced in the catalogue; my gratitude is infinite.

Finally, but most importantly, I would like to express my appreciation to the National Galleries of Scotland for inviting me to curate this exhibition and to thank all those within the Galleries who have worked with me on this project.

CATHERINE WILLS

JOHN BALLANTYNE 1815–1897
Sir Francis Grant in his Studio, 1866
Detail · National Portrait Gallery, London
(cat.no.12)

THE LIFE
AND ART OF SIR
FRANCIS GRANT
1803–1878

I

BACKGROUND,
EARLY LIFE AND VIEWS
ON PAINTING

Francis Grant was born on 18 January 1803 in Edinburgh. He was the fifth child and fourth son of Francis Grant of Kilgraston and his wife, Anne Oliphant of Rossie. The elder Francis Grant had inherited Kilgraston near Perth, and large Jamaican estates, in 1793 from his brother John.

John Grant had demolished the old house at Kilgraston in 1790 and replaced it with a grand red sandstone neoclassical Adam-style building [PLATE 1]. The young Francis Grant spent his childhood summers at Kilgraston, described as it was in the 1820s in Neale's *Views*:

The mansion is pleasantly situated in a well wooded park of considerable extent, surrounded by bold and picturesque hills. The architecture of Kilgraston is Grecian ... the home grounds are laid out in beautiful shrubberies and flower gardens, kept in the best order, and the rides on the neighbouring heights command the most extensive and beautiful views.[1]

Winters were spent mainly in Edinburgh, where Anne Grant was a well-known hostess. Francis was educated at Harrow from January 1814 to July 1816, and then at Edinburgh High School. In 1818 his father died, leaving Kilgraston to Francis's eldest brother, John. The younger children each received the considerable fortune of £10,000. Francis's favourite, and youngest, brother, Hope (later better known as General Sir James Hope Grant), remarked in his journal that 'This was a handsome patrimony and left us all comparatively well off. But such portions to younger children often do more harm than good, and cause idleness and extravagance.'[2]

From 1819 to 1821 Frank, as Francis Grant was commonly called, attended classes at Edinburgh University but failed to graduate. Walter Scott wrote of him in his *Journal*:
In youth, that is in extreme youth, he was passionately fond of fox hunting and other sports. He also had a strong passion for painting and had a little collection ... he used to avow his intention to spend his patrimony, about £10,000, and then again to make his fortune by the law. The first he soon accomplished, but the law is not a profession so easily acquired, nor did Frank's talent lie in that direction. His passion for painting turned out better.[3]

In his journal Hope Grant described how Frank decided to give up the law in favour of painting:
Francis, in his youth, had always a great love for painting and used constantly to attend the studios of the celebrated artists of the day. He painted a picture of me [in 1826] ... My mother ... [and] my brother John agreed to have it put up to friendly auction and it was knocked down for £10 to John ... Francis was at that time studying for the law, which he detested, and an instructor used to coach him daily in Greek and Latin. But the money he had received for his picture, as well as the attendant compliments, completely changed his views for the future and to be a painter was the sole object of his ambition. When his tutor next appeared he informed him of his intention of abandoning the law and becoming an artist. His preceptor was highly amused at what he considered little more than chaff, and opened the books to begin instruction. But my brother coolly took up books and papers, tore them to pieces, and threw them into the fire; to the amazement and consternation of the worthy tutor, who walked out of the house in pitying indignation, and was paid off the next day. Lord Elgin, a great lover of Fine Arts, was so pleased with Frank's bold determination that he wrote a letter offering to send him one of his best pictures to copy – a loan which my brother accepted with delight.[4]

As the *Telegraph* recorded at a much later date, '[in] early days, Mr Grant received much encouragement from the Earl of Elgin ... who lent him pictures from his valuable collection – to a Velasquez, a portrait of the Duc d'Olivarez, which he thus had an opportunity of studying, the young artist acknowledged that he owed much of his after success. This is one of the instances, we believe, of a single picture, thoroughly mastered, having a great influence in the training and development of artistic excellence.'[5] Kilgraston itself was noted for having an 'excellent' and 'valuable' picture collection. John Grant had been painted by Henry Raeburn as a young man, and there were other portraits at Kilgraston by Raeburn, Lemuel Abbot and David Martin of which copies by Francis Grant survive. These copies show that he was an accomplished imitator from his earliest days.

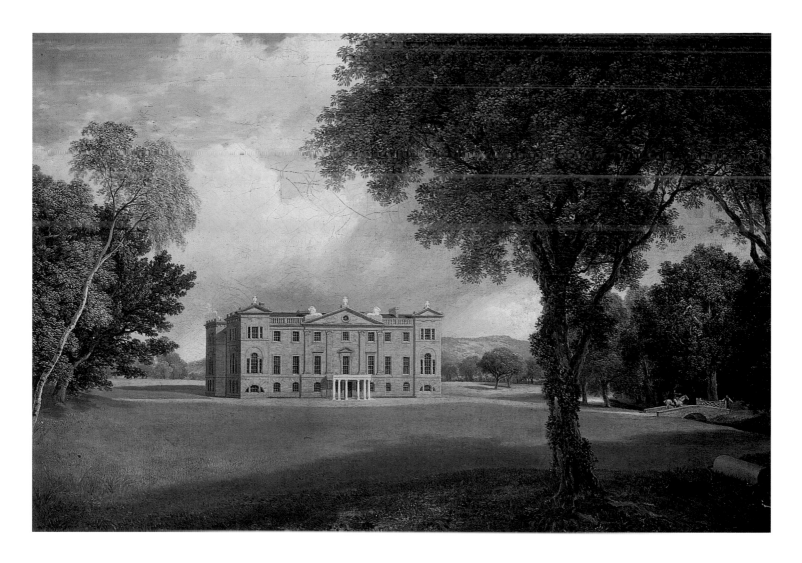

ROBERT GIBB 1801–1837
1. *Kilgraston House, Perthshire*, 1827
Property of Charles G. Spence
(cat.no.1)

On Grant's early training, a contemporary notes that

… when a youth in Edinburgh [he] took lessons in drawing the human figure from Mr George Somerville, who enjoyed much local celebrity as a teacher … Grant began to seriously study art only at the age of twenty-four – previous to this he had received some instruction in Edinburgh from Alexander Nasmyth, after which he began to make copies from works by some of the old masters.[6]

Nasmyth had one of the largest studios in Edinburgh, with many pupils, including the young John Watson (later Watson Gordon). Although now seen as the founder of the Scottish landscape tradition, Alexander Nasmyth had worked as an assistant in the Scottish portraitist Allan Ramsay's London studio and, on return to Edinburgh in 1778, had started practising as a portrait painter.

That Grant as a youth was more than familiar with the principal Edinburgh studios, is shown in a letter he wrote to *Blackwood's*

Magazine in the 1820s: 'You will receive from me before the end of this week a paper on the fine arts … The principal subject is a visit to W. Allan. If the papers are continued, the works of all the principal artists will be reviewed successively …'[7] William Allan was one of the most interesting and most technically accomplished of the early nineteenth-century Edinburgh painters. He spent nine years in Russia, from 1805 to 1814, and had great success with his Russian subject pictures on his return to Scotland. He was also an excellent portraitist. He portrayed himself in Circassian clothes and his studio was said to be one of the sights of Scotland:

The land itself of gems and tiaras, and Bashaws and Banditti … full of military accoutrement, Turkish scimitars, Circassian daggers, Georgian, Armenian and Tartar dirks and javelins, helmets, shields, shawls, saddle cloths and turbans of all descriptions – a veritable Aladdin's cave.[8]

Through his familiarity with Walter Scott and

his family Grant met leading artists when they visited Edinburgh, for they all gravitated to Scott. Like Scott, the landscape painter the Revd John Thomson of Duddingston was another pivotal figure in Edinburgh. In due course he would supply landscape backgrounds for some of Grant's early Scottish pictures. Among Thomson's friends was David Wilkie, who had studied with William Allan and whom Grant greatly admired. A frequent guest at Duddingston was J.M.W. Turner, both during the royal visit of 1822 and again in 1831, by which time Grant himself was spending more and more time in London. The future Pre-Raphaelite painter, William Bell Scott, records one of these occasions:

Francis Grant was one of the guests. It was the day of Reform Bill agitation, and Grant said he had been nearly mobbed in town on his way to dinner – 'But it was the aristocratic horse I rode, no doubt, that attracted attention', he quickly added. Turner saw through the man. Grant had already taken a studio in London and Turner pretended to know the locality which he described. 'I know the werry place', he said, 'it's where the bear gardens used to be.' [9]

Edinburgh in the 1820s was no artistic backwater, with Raeburn at the height of his fame. Wilkie mentions in a letter of 1823 that Thomas Phillips the portrait painter had been there and in September 1824 Wilkie again writes: 'The artists of Edinburgh, to the number of seventeen, with Mr Nasmyth at their head, agreed to give me a dinner at the British Hotel … Young Landseer was also invited.'[10] This records Edwin Landseer's first visit to Scotland and he and Grant were to become the closest of friends. In the same month Wilkie mentions both Richard Westmacott and George Leslie being there, Leslie to paint his life-size portrait of Scott.

Grant had extensive art historical knowledge and by the mid-1820s, when he was still living mainly in Scotland, he had built up a collection of old master paintings, largely seventeenth-century Italian, Dutch and Flemish works. This contributed to his financial problems at this time, which are hinted at in a letter (almost certainly to Thomson of Duddingston):

With regard to the small picture, … send it to the exhibition and ask £12 for it – if no one buys it at that, I will be in town in April and will take it at £10 … I hope it shall be sold as I have promised to buy no more pictures for this some time – but I shall not be able to resist it if I see it again.[11]

The Earl of Wemyss mentions Grant as 'having spent his portion in hunting … and among sharper whist players than himself'.[12] By 1827, only nine years after receiving his inheritance, he had run out of money and was forced to sell his collection. Grant himself wrote the detailed catalogue, but as it was concerned with boosting the value of the paintings it is not very revealing about his artistic perceptions.

However, the catalogue which Grant made of Lord Gray's collection at Kinfauns Castle (the two families were connected by marriage) shows the breadth of his knowledge, and his sensitivity to works of art. Begun in 1827, it was published in 1833 and is a vitally important document. It shows a familiarity with the writings of De Piles, Vasari, Houbraken, Sandrart, Joshua Reynolds, and, above all, Matthew Pilkington. Pilkington's *The Gentleman's and Connoisseur's Dictionary of Painters*, rambling, fanciful and pedantic, influenced Grant's style in the Kinfauns catalogue, but this does not hide his genuine enthusiasm for the painterly qualities of the works described.

He shows great admiration for the Scottish school of painting, praising particularly Alexander Runciman and John Watson Gordon. However, it was Henry Raeburn, who had died as recently as 1823, whom he held in the highest regard, remarking that 'his name will be classed with a Van Dyck and a Reynolds'.[13] These latter two were the artists most admired by Grant, and Reynolds in particular was to be his greatest hero and role model. Another English painter whom he praises is John Hoppner, especially for his combination of portraiture and landscape, something to which he attached great importance.

Grant also greatly admired David Wilkie, whom he probably knew quite well. He alludes to Wilkie in his 1873 presidential discourse (one of four to survive) delivered to the students at the Royal Academy:

The subject painter must have beauty and

grace in his female figures, manliness and dignity and faultless drawing in his male figures. His colouring must be strong, yet harmonious, his grouping felicitous, there must be beauty and refinement combined with nature pervading the whole picture if it is to be a success. We have a fine example of all these qualities in the works of Wilkie.[14]

However, he did not admire Wilkie's portraits: *I would venture to say as a general rule he was not successful in portraiture. I remember being invited with others to visit his studio … when a full length portrait of the Queen was exposed to view, a very ominous silence followed … at last someone ventured to say that it was a fine picture, but it was not a good likeness of Her Majesty, to which Wilkie, with his Scotch accent and kindly smile said, 'Well, well, you know it will be like enough a hundred years hence.' A very comforting reflection, if it were true, which however is very doubtful.*[15]

Grant also discusses portrait painting in general terms in the 1873 discourse:
Truth to nature should be combined with taste and refinement … I do not mean to advocate commonplace flattery in portraiture, but I think there is little danger on that score. Sir Thomas Lawrence spoke truly when, being accused of flattery in his portraits, his answer was: 'I never in my life succeeded in flattering so much, but that at certain periods during the progress of the picture, my sitters looked infinitely better than I was able to represent them.'[16]

Despite this admiring reference to Lawrence, Grant deeply resented the frequent comparisons made between them, as his annotation on a publisher's biographical notice makes clear:
I have taken the liberty to draw my pen through the part which notes that I had caught the style of Lawrence, for he is the last man I should wish to imitate – though he undoubtedly painted several very fine works – but in a general way his style is monotonous and affected, I think. What I have aimed at is truth and character combined with refinement, however imperfectly I have succeeded.[17]

Nevertheless, there is some justification for the comparison which so much incensed him. This is evident in Grant's wonderfully romantic portrait of the statesman Benjamin

Disraeli. The French critics, at the Paris *Exposition Universelle* of 1855, also recognised this similarity and one of them called Grant 'the most direct beneficiary of Lawrence's qualities'.[18] Certainly their social roles were seen as similar, as one of Grant's obituarists would point out:

[he] was called upon to paint a larger share of the celebrities of [his] generation than fell to the lot of any other contemporary portraitist. It may also be said of him that he gradually succeeded to a good deal of the practises of Sir Thomas Lawrence, who had died in 1830, just before Francis Grant began to exhibit.[19]

Grant saw the social virtues as important attributes of the great painter, for, he believed, they 'refine the mind which in turn improves the work in progress'.[20] Yet he wanted to be seen as a serious painter and not merely as a painter of high society. He felt called upon, as so many painters had done, to defend the status of portrait painting, saying, 'It is no inferior branch of Art, but, on the contrary, one of the most important and certainly one of the most difficult.' As part of his defence he reverts to the example of his favourite, Reynolds, whose 'cultivated mind' he so much admired: 'Among the greatest masters in this branch of Art we must certainly reckon Sir Joshua Reynolds. His male portraits are remarkable, not only for their individuality and character, but they most frequently possess a dignified demeanour and a look of thoughtful intellectual superiority, whilst his female portraits have never been surpassed for grace and perfect purity of sentiment, combined to singular truth to nature.'[21] These are the qualities to which Grant would aspire.

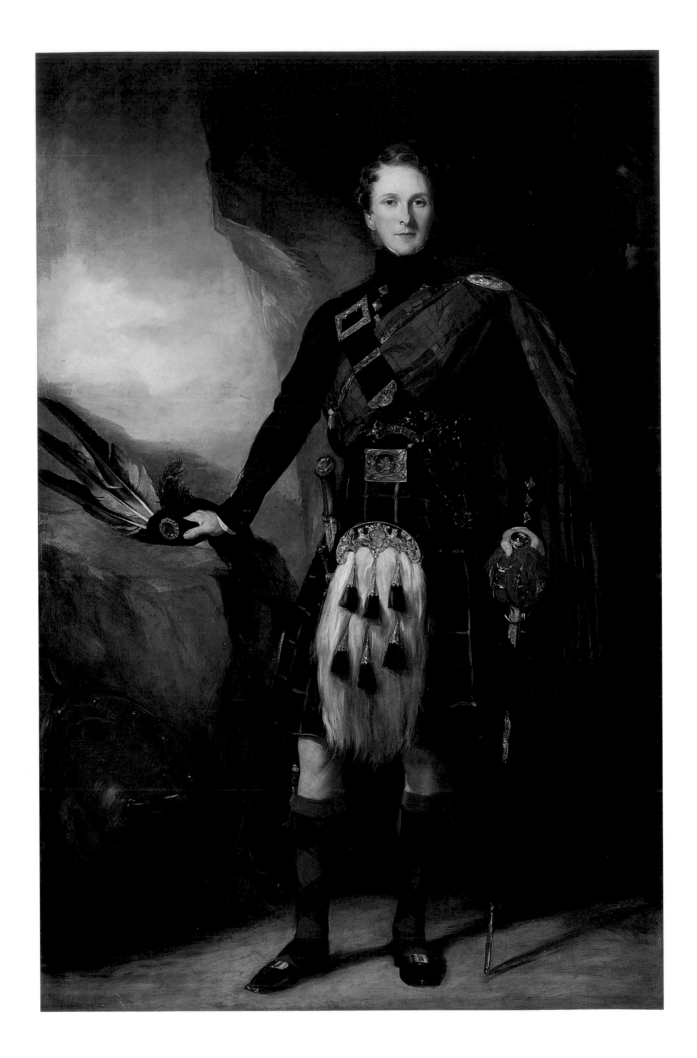

FRANCIS GRANT'S MARRIAGES AND LIFE AT MELTON MOWBRAY

On 19 April 1826 Grant married Amelia Farquharson of Invercauld. According to family tradition the marriage was an elopement, the ceremony taking place in the housekeeper's room at Kilgraston. The Farquharsons of Invercauld were one of the largest landowning families in Scotland. Eleanor Stanley, maid of honour to Queen Victoria, wrote of them:

The Farquharsons are the Marquis of Carabas of this part of the world, the Queen says they have a tract of sixty miles of country about here, but adds that they are such kind neighbours that they allow her and the Prince to do whatever they like in the part near Balmoral … The Queen says Invercauld is the finest place she has ever seen …[22]

It is likely that the prospect of the daughter of such a family marrying a younger son with apparently few prospects did not enthral the Farquharsons, however good looking and charming he might be. Once married, though, Grant was a frequent visitor to Invercauld, and remained a lifelong friend of his brother-in-law James Farquharson, whose portrait in Highland dress he was to paint in 1844 [PLATE 2].

Amelia, or Emily, as she called herself, made up an album of her husband's drawings and etchings dating from 1820 onwards. These include Grant's first caricature drawings – a long series with which he amused himself throughout his life. A large proportion of the drawings in the album are after old masters. Later drawings tend to be almost entirely of contemporaries and day-to-day events. The etchings, the only surviving ones made by Grant, are all after old masters and may be some of the ones he mentions making for the Kinfauns catalogue, but which were never used.

Grant's earliest oil paintings are almost entirely family portraits, all done on a small scale and tightly painted. These include three of Amelia, one of them showing her on horseback, and an extraordinarily glamorous self-portrait, wearing a Farquharson tartan waistcoat and with a telescope strapped around his shoulders. This painting is on a scarlet ground which Grant was still sometimes using as late as the 1850s. Another work of about 1826 shows James Farquharson with two foresters and a dead stag in rugged hills. It is influenced by the work of the sporting painter John Ferneley and also anticipates the pictures of deer which Grant painted in the final years of his life. It is small in scale, the portraits convincing but the figures wooden and the perspective faulty.

Grant's earliest hunting picture, probably from about 1825, is *The Perth Hunt*, the local hunt to Kilgraston, of which his brother John was to become Master for a few years around 1840. It is distinctly amateurish, and evidence that an equestrian group portrait was too ambitious for Grant at this stage in his career. The horses are more convincing than the hounds but only the portrait heads have any quality and anticipate the superb small heads in Grant's later hunt pictures. The landscape background consists of thinly painted grey sky, distant hills and detailed undergrowth. Its qualities, however, are likely to be due to either John Thomson of Duddingston or the landscape painter Robert Gibb, both of whom are recorded painting landscape backgrounds for Grant's pictures when he worked in Scotland in the 1820s and '30s.

Grant is first recorded in Melton Mowbray in Leicestershire in about 1820. It was the home of John Ferneley and also the mecca of the foxhunting world. Grant was inevitably attracted to the place by the hunting as well as by 'the best society in the world' which included statesmen and diplomats from all over Europe. Its atmosphere was described in 1835 by C.J. Apperley ('Nimrod') in these terms:

The flower of our English youth … (or those at least worth looking at) have always been to be seen there, and a winter in Leicestershire has ever been found to be, to those who are entitled to it, the 'passe partout' that leads to the best society in the world.[23]

That Grant originally went to Melton Mowbray in the company of his brothers is suggested by Ferneley's group portrait of Grant with his brothers John and Henry, painted in 1823 [PLATE 3]. Ferneley stayed at Kilgraston the following year, probably on his way to Mar Lodge in Perthshire where he and Grant and other friends used to go deer stalking together. Grant also commissioned several portraits of

2. *James Farquharson of Invercauld*, 1844
Trustees of the Captain Farquharson's Invercauld Trust (cat.no.16)

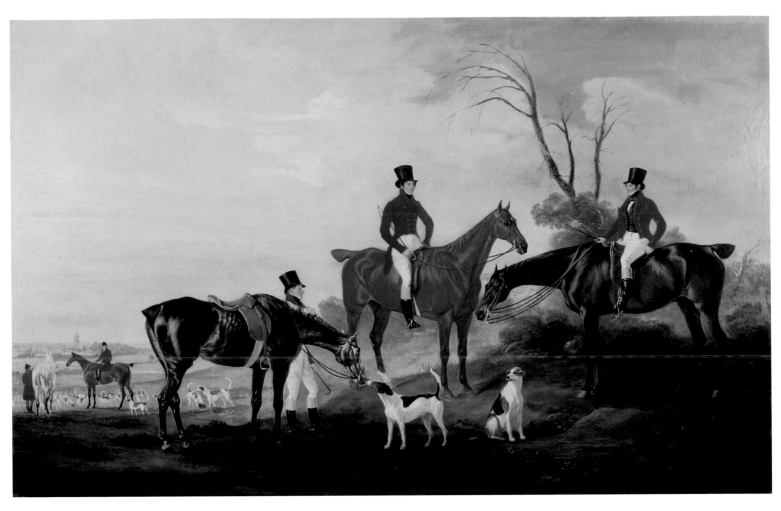

horses from Ferneley and they collaborated on a number of pictures, Ferneley painting the horses and Grant the portraits of the riders. This was done in individual equestrian portraits as well as in some of Ferneley's big hunting pictures such as *The Belvoir Hunt* of 1827.

The flavour of Grant's life at Melton Mowbray is amusingly described by Nimrod in his *Hunting Tours*:

At Melton Mowbray, as may be supposed, are persons from all parts of His Majesty's dominions, and Ireland and Scotland furnish their share. The house occupied by Mr Smith Barry and Mr O'Neill, and that inhabited by Captain Ross and the two Messrs Grant, stood exactly opposite each other … and from the unbounded hospitality which was displayed in them, they might almost have been mistaken for the signs of the shamrock and the thistle. There was neither difference nor distinction in the good fellowship that prevailed, in the excellence of their French cooks, or in the streams of claret that flowed round their well-polished mahogany. Mr Francis Grant does not

return to Melton, which I was very sorry to learn. I was in hopes once more to have listened to the lively sallies of this fine young Scotchman who reminded me of the wild landscapes of his parent country.[24]

In 1825 Grant was involved in a wild escapade with Lord Howth from whom he won a bet of £1,000 that he could jump a gate with his horse's front legs between the rear legs of the latter's horse. This feat was recorded in a painting by Ferneley, with the portraits painted by Grant. A less successful incident is recorded in an engraving after a drawing by Grant which shows him in hunting clothes lying on the landing side of a large obstacle with a horse spreadeagled on top of him. The engraving, which was included in Emily Grant's album, bears the inscription 'From a drawing by F. Grant of his severe fall in Leicestershire'.

Nimrod, at a later date (1838), in a commentary he wrote for the engraving of Grant's painting *The Ascot Hunt*, gives another picture of these kinds of activities in the early 1820s – ones that led to the dissipation of

Grant's fortune and ultimately to the sale of his picture collection:

The last time I had the pleasure of seeing this gentleman in the sporting world, he was in the character of an artist of a different description … He was, in truth, exhibiting at a place called Melton Mowbray and in its vicinity the combined arts of riding over not only fences and brooks, but now and then over horses and men, in the morning, and delighting society in the evening by the sallies of his wit and humour. In the course of his performance in the field he lamed twelve out of fourteen hunters, which was the precise state of his stud at the close of that memorable season.[25]

In 1827, Grant lost his wife Amelia (Emily) after the birth of their son, John Emilius Grant. He was deeply upset by her death. In the following two years he spent some time at Melton Mowbray but must also have visited London on a number of occasions. In July 1829 he married his second wife, Isabella Norman, a niece of the Duke of Rutland, whose parents lived in Leicestershire but who, during the summer season, lived with her grandmother, the Duchess of Rutland, in London.

Walter Scott described the circumstances of Grant's second marriage:

Francis Grant was very much the man of fashion … At Melton Mowbray, during the hunting season, he had become acquainted (even before his first marriage) with a niece of the Duke of Rutland, a beautiful and fashionable young woman with whom he was thrown into company once more. It was a natural consequence that they should marry. The lady had not much wealth, but excellent connections in society, to which Grant's good looks and good breeding made him very acceptable. In the meantime Frank saw the necessity of doing something to keep himself independent … and honourably and manfully resolved to cultivate his taste for painting and become a professional artist. I am no judging [sic] *of painting, but I am conscious that Frank Grant possesses, with much taste, a sense of beauty derived from the best source, that of really good society … His former acquaintances render his immediate entrance into business completely secure and it will rest with himself to carry out his success. He has, I think, that degree of energy and character which will make him*

keep and enlarge any character which he may acquire. He has confidence too in his own powers, always a requisite for a young painter whose aristocratic pretentions will be envied.[26]

The significance of Grant's second marriage cannot be overestimated for the pursuit of his career. Isabella may not have been a potential heiress like Amelia Farquharson, but through her Grant was accepted into the immediate circle of the Duke of Rutland, the focal point of Melton Mowbray society. As Guy Paget writes in his *The Melton Mowbray of John Ferneley*, 'The family of Manners [that is, the family of the Duke of Rutland] dominated Melton, as their estate dominates the Belvoir Vale'. Grant frequented the Duke's, and later his son's, hunting and shooting parties for the rest of his life, and was on good enough terms with the then Marquis of Granby to travel to Belgium, Holland and Paris with him in the autumn of 1844. Grant's connections with this family had important consequences, not least for the Royal Academy.

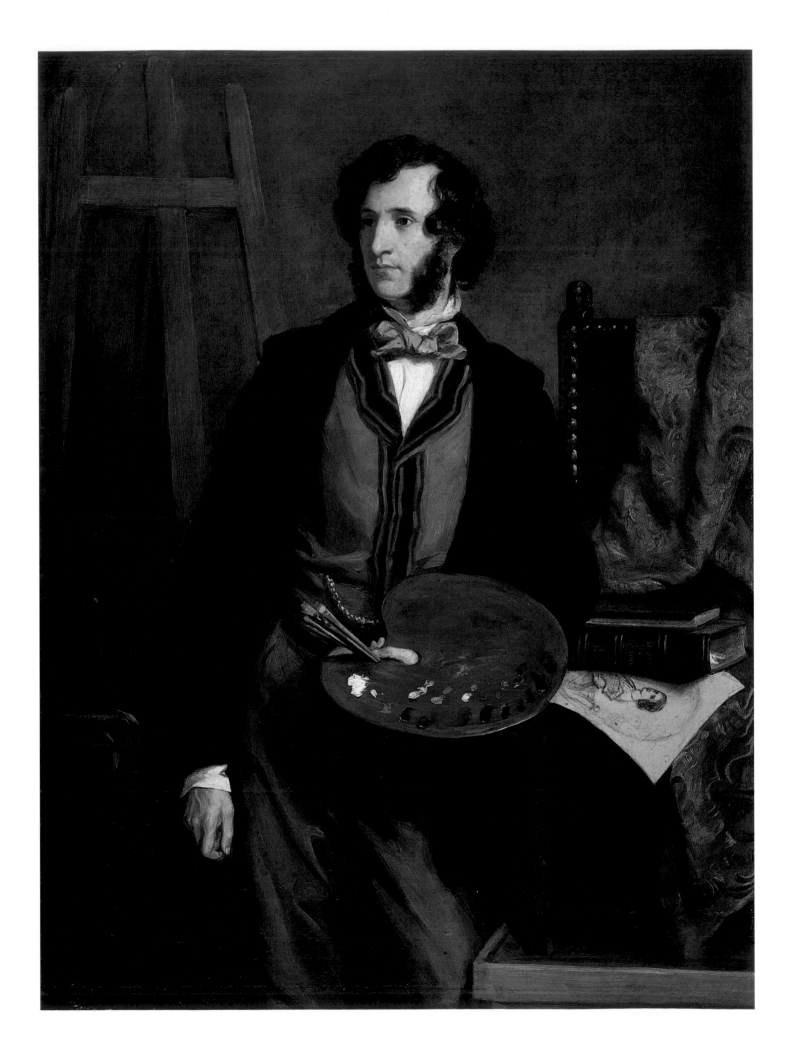

3

SCOTLAND AGAIN

From the summer of 1827, Grant lived in Scotland and did not return to Melton until 1833. During this period he exhibited his first work at the inaugural exhibition of the Scottish Academy in Edinburgh in 1827. That Grant had acquired a good technical knowledge of painting by 1829, and a far deeper one than would have been obtained by a mere amateur, is illustrated by a uniquely interesting letter that he wrote to the Countess of Mansfield on the subject of portraiture. It is by far the most detailed surviving letter that Grant ever wrote about painting. Most of his letters, even to Landseer, hardly mention the subject, and are about shooting, hunting, Scotland, family or Royal Academy matters. He remarks on how much easier oil painting is than watercolour, and then goes on to explain glazing and how to paint shadows, exactly which colours to use when painting a face and how to mix them. Other topics are how to obtain 'brilliance of colour', rather than 'chalkyness and mud', how to lay on lights and how to hatch. He ends his letter by saying that if Lady Mansfield has time to go to William Allan's studio when she is in Edinburgh, she will be interested in what he is painting. This may well imply that Grant had learnt the art of portraiture from Allan. Another Scottish artist influenced by William Allan was James Rannie Swinton whose portrait Grant painted in 1850 [PLATE 4].

From 1828 until the end of Grant's career, Isabella, his second wife, kept a list of a great number of Grant's paintings and the prices received for them. The book is a vital source of information although it is neither complete nor totally reliable, despite being described by Grant's daughter Elizabeth as 'a list of all the portraits painted by my father'.[27] Several works known to have been exhibited at the Royal Academy are not entered, nor are family pictures, since they were not usually commissions. On several occasions payment was in kind – and Grant was given a horse. Paintings were sometimes entered long after they were finished, sometimes even after they had been exhibited. All the early sitters were Scottish, and, apart from *A Battle Piece Painted from Imagination* entered in 1829, Grant's output at this time was confined to portraits.

In 1829 Grant was one of twenty-four artists, including John Watson Gordon, who successfully applied to join the Scottish Academy, which in that year received its royal charter and became the Royal Scottish Academy. He exhibited there, but also sent works to the rival Royal Institution for the Encouragement of the Fine Arts in Scotland. The Academy quickly became by far the more important of the two institutions and Grant exhibited seven paintings there in 1831. These included his diploma picture, *Head of a Jew*, which he had painted in 1823/4. Heavily influenced by Rembrandt, its condition has since badly deteriorated.

Grant's first important commission was from Lady Ruthven in 1831. This was for a portrait of Sir Walter Scott, which was entered in the sitters' book under February 1832 as 'Sir Walter Scott, painted at Abbotsford in his study, whilst dictating Count Robert of Paris, with his greyhounds'. Both Scott and Grant describe the sittings and Scott was pleased with the finished work, saying, 'Frank Grant has made a good portrait of me for Lady Ruthven … and the addition of two large deer hounds has given an interest to the performance which it could hardly have gained otherwise'.[28] Scott obviously had Grant's welfare much at heart. He had already commented to his son-in-law, John Gibson Lockhart, when Grant was at Abbotsford: 'Here is Frank Grant painting a cabinet picture of myself and the two dogs. The last at least a fine subject. If he gets through with it as he is like to do – it will be of service to him in London.'[29] Despite its mixture of eighteenth-century grand manner accessories, such as the red curtain and the armour, with highly finished detail, especially in Scott's face (though not in the rather sketchy, unresolved hands), the work was generally admired [PLATE 5].

Grant's next important work was *The First Meeting of North Berwick Golf Club*, painted in 1832. In essence a conversation picture, it has an economy of treatment and stark simplicity of design, as well as an interest in silhouette that comes close to the work of, not Ferneley, but the latter's master, Ben Marshall, who was nearing the end of his career as the leading equestrian painter of his day.

4. *James Rannie Swinton*, 1850
Private Collection (cat.no.52)

19

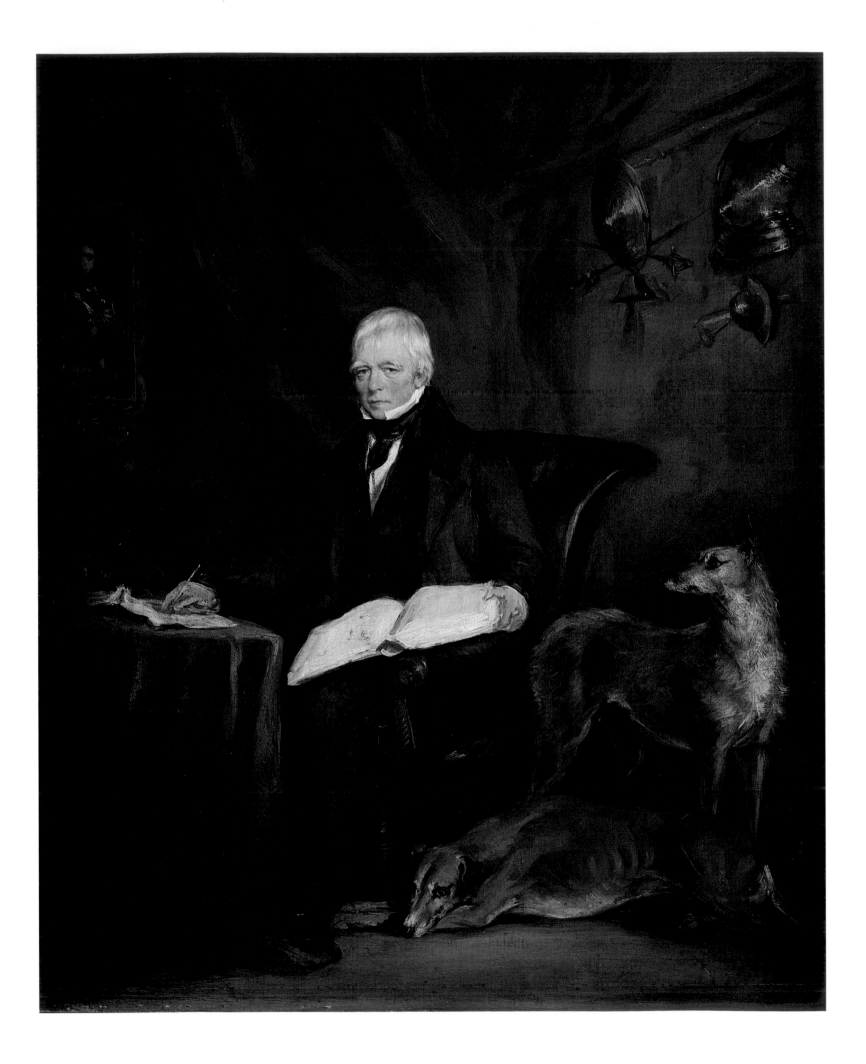

It was in the following year that Grant painted his first two important hunt pictures, *A Meet of the Buccleuch Hounds* [PLATE 6] and *A Meet of the Fife Hounds* [PLATE 7], both for Lord Kintore, with whom the painter seems to have been friendly. Lord Kintore already owned several paintings by Ferneley, including *A Meet of the Keith Hall Foxhounds* of 1824, and Grant's two paintings imitate Ferneley's arrangement of his protagonists. Both painters place a horse seen from the rear to the side of the canvas, there is a similar mix of mounted and standing figures, the hounds are grouped around them in a similar fashion, and there are small secondary figures in the background. The horses and hounds are depicted so as to be individually recognisable (Grant's pictures were given engraved keys) and there are specific views in the background – the Eildon Hills and the duke's kennels in the Buccleuch

picture for example, though these features were probably painted by Thomson of Duddingston.

Despite these similarities to Ferneley, however, there are marked differences in their works. Grant's horses and hounds are fairly broadly painted, while Ferneley is much more sensitive to the textures of the animals' skins. On the other hand, Grant's figures are much more convincing than Ferneley's and the portrait heads are far more individualised. More generally, Ferneley's canvases are much larger than Grant's at this time and his large, imposing thoroughbreds tend to dwarf their riders. By contrast, Grant's hunt groups tend to consist of highly individualised riders and more mundane horses. They are far more informal, relaxed and intimate, without any particular glamour.

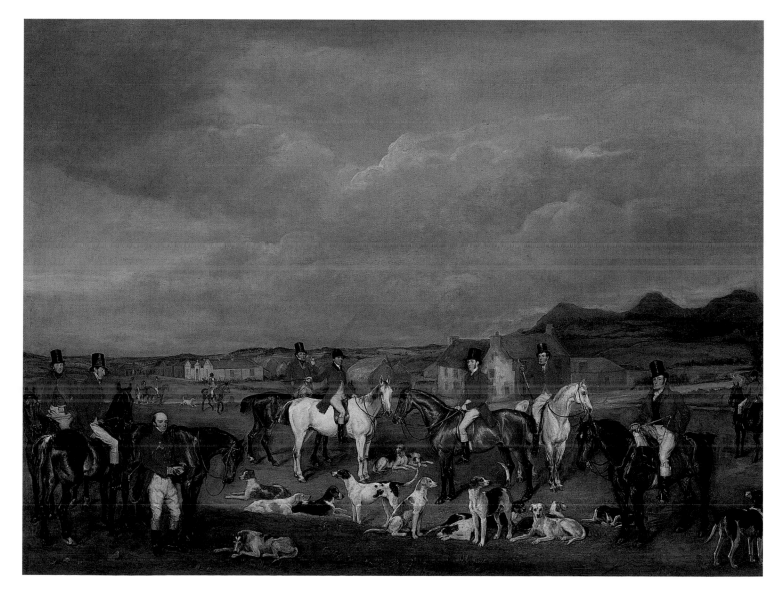

7. *A Meet of the Fife Hounds*, 1833
On loan from the Kintore Trust, Scottish
National Portrait Gallery, Edinburgh
(cat.no.17)

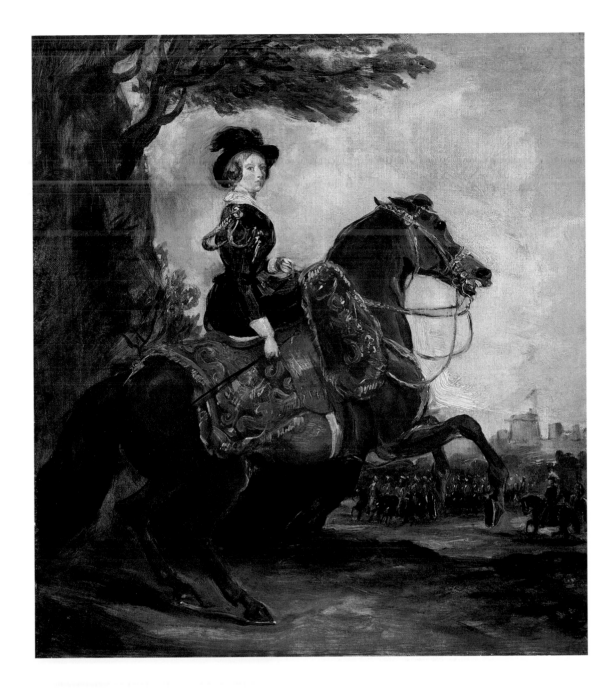

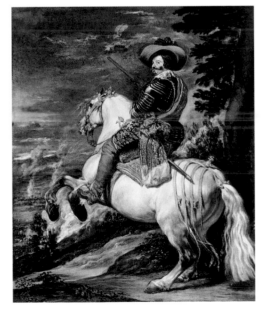

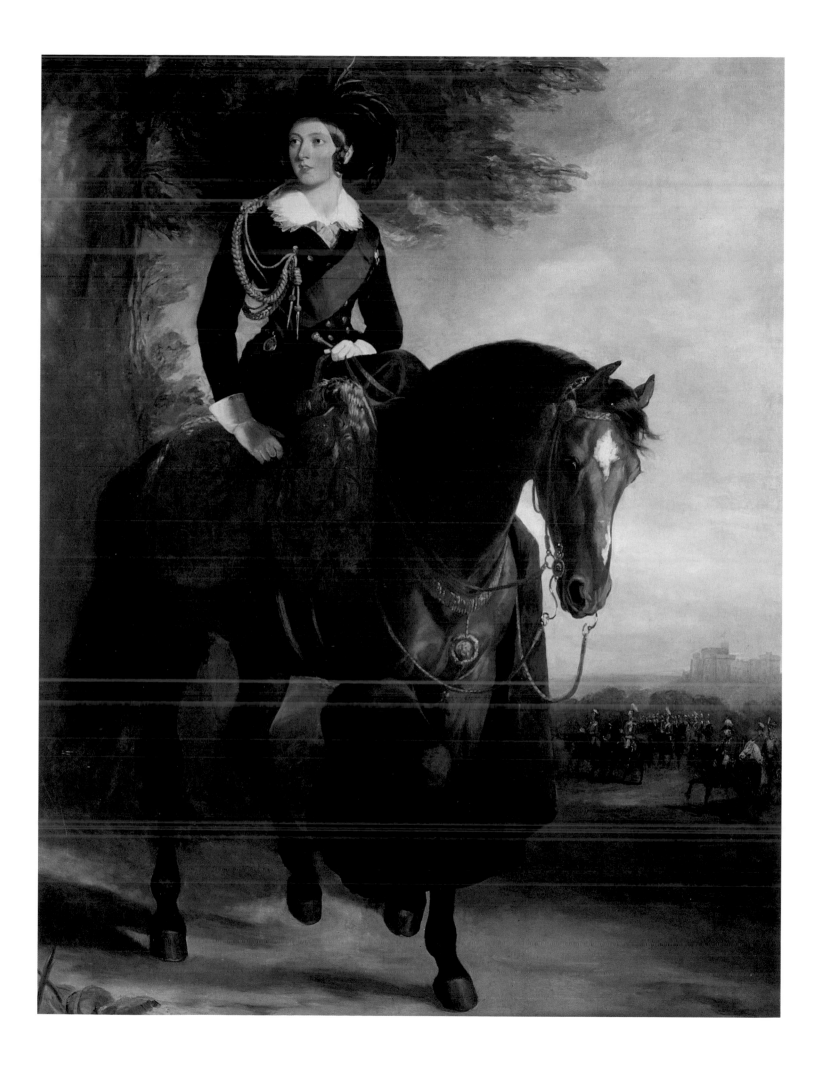

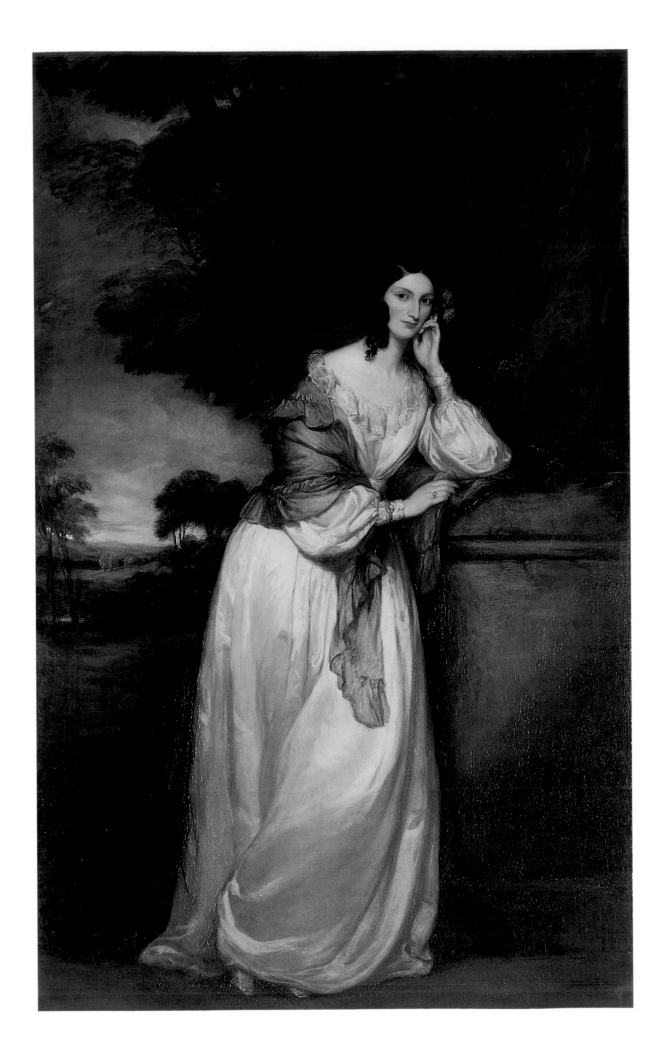

6

OTHER WORKS OF THE
LATE 1830S AND EARLY
1840S

At the same time as he was making these royal portraits, Grant was painting portraits for a number of the great houses of England and Scotland. A characteristic of these portraits is that they often seem to have been affected in their approach by the collections of paintings already in the houses. An example is Rossie Priory in Perthshire, home of Grant's great friend, the 9th Lord Kinnaird, for whom in 1838 he painted a pair of bust-size portraits of Kinnaird and his wife. Rossie Priory had a notable collection of old master paintings, particularly Italian ones, and Grant's portraits are markedly Italianate in feeling, especially that of Lady Kinnaird which is overtly Leonardesque.

For Ickworth, which contains a considerable number of impressive portraits by Reynolds, Gainsborough, Hoppner and Lawrence, Grant was commissioned in 1839 to paint portraits of Frederick William, Earl Jermyn and his wife Katherine (who was a daughter of the Duke of Rutland) for the dining-room [PLATE 18]. It was the local Suffolk painter, Thomas Gainsborough, who exercised the greatest influence here. A rather languid, insubstantial Lady Katherine Jermyn, standing in parkland, her elbow on a stone tomb, recalls the composition of Gainsborough's *Mary, Duchess of Richmond* at Ascott. The freely painted landscape is also reminiscent of Gainsborough, although the figure is painted with a far higher degree of finish. In the portrait of an alert and forceful Lord Jermyn, Gainsborough's influence is most strongly evident in the broadly brushed background, with its rich chestnuts and smoky turquoises and thinly painted clouds and distant landscape.

Again, when Grant painted a full-length of *The Duchess of Buccleuch and her Two Eldest Sons* in 1838 and a portrait of her youngest son, *Lord Charles Scott*, in 1842, he was especially conscious, not surprisingly, of the portraits by Joshua Reynolds in the Duke's collection at Bowhill. The portrait of the duchess and her sons has much of the feeling of Reynolds's *Lady Cockburn and her Children* and something of an eighteenth-century pastoral mood. The children seem part of that mood, while the duchess, because of her early Victorian hair style, which

incorporates pink roses, is more contemporary in feeling. The sheer formality of this work makes an interesting contrast with Grant's very informal drawing of the duchess with one of the boys [PLATE 20].

The portrait of *Lord Charles Scott* [PLATE 21] quotes directly from Reynolds's iconic portrait of *Lady Caroline Scott as Winter* [PLATE 19] and has much of the same charm. As in the Reynolds, the child is shown full face at eye level with the viewer. Lord Charles wears a wide skirt, a white lacy shirt and a straw hat with turquoise ribbons and plumes, which is a direct quotation of Lady Caroline Scott's hat. The black and white King Charles spaniel on a ribbon is perhaps an allusion to the boy's name.

This portrait is one of a number of masterly portraits of children that Grant painted in these years. Among them is a double portrait of the Ladies Louisa and Beatrice Legge – *The Two Children of the Earl of Dartmouth with a Pony*. It too owes something to Reynolds's manner but is essentially decorative in a nineteenth-century way – the pony is painted with a virtuosity that comes close to Landseer. The same kind of charm is present in a small sketch of the Ladies Susan and Constance Murray [PLATE 22] which was painted in 1841.

Very different from these pictures of children is Grant's portrait sketch of his son Francis – a free and spontaneous image of a child with a fishing rod, painted for Grant's own pleasure. Francis was born in 1834 so that the painting is likely to have been made about 1842. In contrast to the looseness of the background, the child's face has a porcelain-like smoothness of detail, the handling of the whole showing Grant's enormous virtuosity.

Another child portrait of about the same date is that of *Master George Byng* [PLATE 36], son of Grant's friend George Byng, who had been included in *Queen Victoria Riding Out*. The boy sits on a ledge under a rock with a book on his knee and a dog at his feet. Again, his face is smoothly painted and rather idealised in a way that is close to some of the child portraits of Thomas Lawrence. The romantic, richly coloured landscape, however, is closer to Gainsborough.

Two other children's portraits of this time

18. *Lady Jermyn*
Ickworth, The National Trust

SIR JOSHUA REYNOLDS 1723–1792
19. *Lady Caroline Scott as Winter*
Collection of the Duke of Buccleuch and
Queensberry KT

deserve attention. The portrait called *Master Talbot*, a small work painted in 1843, is an interesting example of Grant exploiting a previously used composition in an entirely different context. The boy, leaning against his spirited palomino pony echoes Grant's life-size portrait of *The Earl of Zetland with his Horse* which he had painted two years earlier. In the latter portrait the earl is shown in three-quarter view beside his grey horse, holding his reins and top hat against the horse's neck, a composition which Grant had probably originally derived from Reynolds's *Captain Robert Orme* or Gainsborough's *Viscount Ligonier*.

The painting, *Master James Fraser on his Pony* [PLATE 23] of 1844 shows a young boy on a chestnut pony with a distinctly Arabian head and a flowing mane and tail. The white of its eye is visible and it appears nervous and highly strung, its fiery look accentuated by its open mouth and steaming nostrils. The concept of the portrait was probably taken from a much earlier painting by Landseer, his *Lord Cosmo Russell on his Pony Fingal* of 1824, and the delicacy of the painting of the face is also close to Landseer.

Grant's growing success can be illustrated by a series of letters written by Lord Minto in the early 1840s to his wife in Scotland in which he speaks of his portrait by Grant that was currently underway – now unfortunately only known from a copy. Not only do the letters show how sought after Grant was, but they also say much about how he worked – starting pictures from sittings in London during the summer and completing them, or nearly so, either at Melton Mowbray in the winter, between days of hunting or shooting, or again back in London. They also show that Grant was not averse to flattering his sitters. Lord Minto's first letter is from London on 7 June 1842:

I have been a great deal too amiable and went yesterday to Mr Grant's with very much the same feelings that one carries to dentists. I thought from his conversation with Lord Palmerston and Lord Ashley who were there, as well as from the number of portraits in hand, that there was no chance of his undertaking me in the short time I could allow him, but I was caught and he said that tho' he had referred new subjects for this season, he should like to have me as he felt he could succeed. I have

20. *Charlotte Anne, Duchess of Buccleuch and her Son*, 1838
Collection of the Duke of Buccleuch and Queensberry KT (cat.no.65)

21. *Lord Charles Scott*, 1842
Collection of the Duke of Buccleuch and Queensberry KT (cat.no.44)

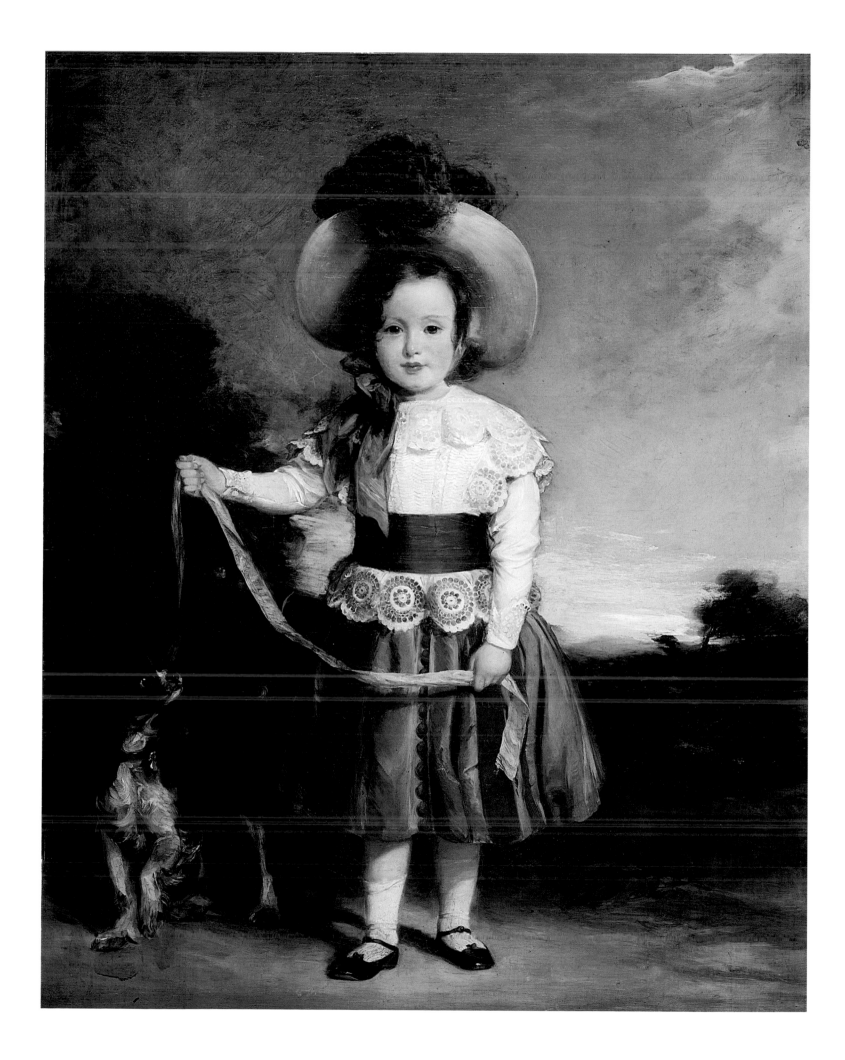

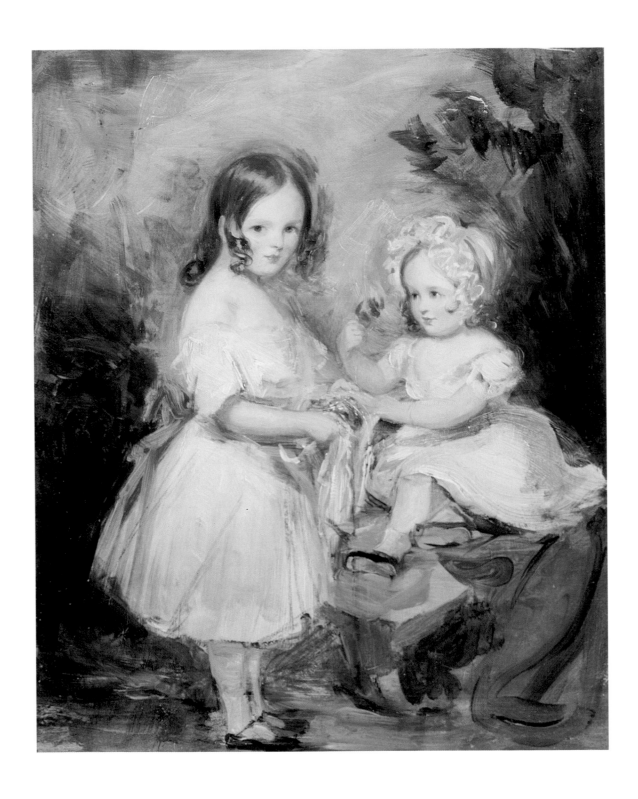

22. *The Ladies Susan and Constance Murray*, 1841
Collection of the Earl of Mansfield, Scone Palace (cat.no.43)

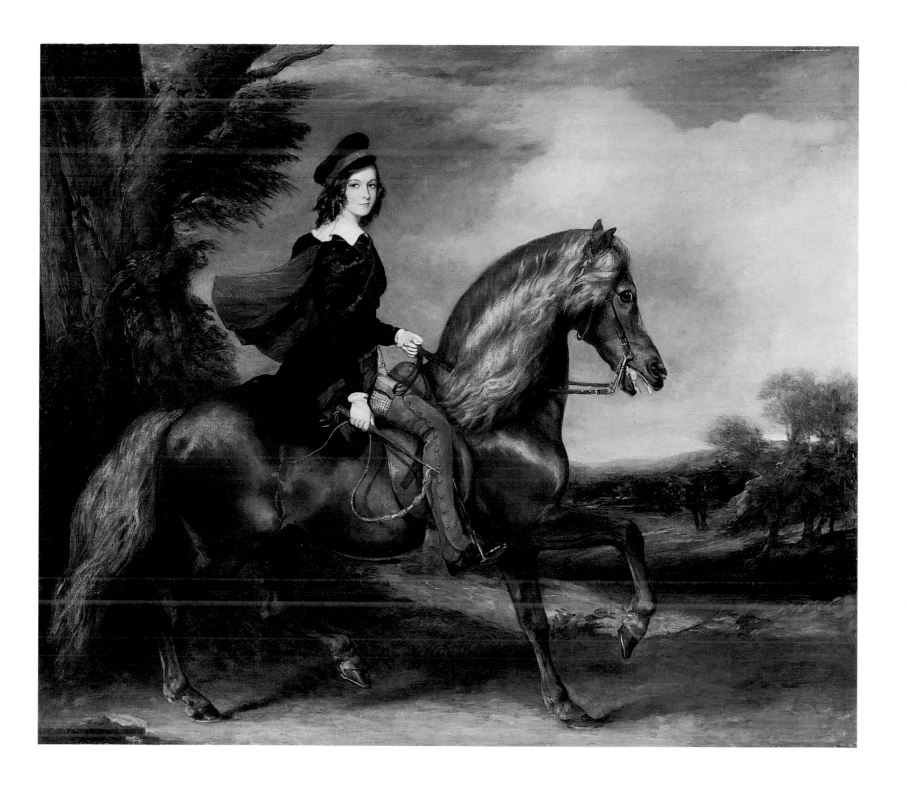

23. *Master James Fraser on his Pony*, 1844
Yale Center for British Art, Paul Mellon Collection (cat.no.47)

therefore promised him certainly one night sitting this week, and as many as he has time for next week after which I hope to be beyond his reach. The pictures I saw in his studio were extremely good, and one of Miss Stewart, pretty far advanced, is quite lovely [Louisa Stewart de Rothsay, later Marchioness of Waterford].[48]

The following day Lord Minto wrote:

The House of Lords has come in the way of my sitting to Grant next Friday, but I am to begin on Monday night and go on regularly. I fancy four or five sittings will advance the thing enough to stand over for winter work in my absence, and a finishing when I may be again within reach.[49]

On 14 June he wrote:

I had my first sitting to Grant last night and am to be with him again tonight. Fanny [his daughter, Lady John Russell] has promised to report progress to you, and is pleased with the beginning.[50]

There is then a gap until 21 February 1843 when Lord Minto again wrote from London:

I went to Grant's to sit to him this morning, and having been warned that he wished my evening coat to sit to him as well as myself, went in a morning frock, and was obliged to borrow one of his much smarter coats than my own for the sitting. He today entirely altered the attitude and position of the arms and I think very much for the better. I go again on Thursday morning to sit.[51]

This is the first reference to a sitter's clothes being given 'sittings' in place of the sitter, a useful expedient for Grant's male sitters who were often public figures with considerable demands on their time. On 22 February Lord Minto wrote once more:

Tomorrow morning Fanny is to accompany me to Grant's where my coat and ribbon and star are to have a sitting.[52]

The next day his letter noted:

I am just returned from a long sitting to Grant, and am to sit again on Saturday and Tuesday which will finish all that is required of me – Grant declares that it is to be the best man's portrait that he has painted, and I think it promises to be a very good picture.[53]

He then writes on 1 March:

I had my last sitting today at Grant's and nothing now remains to be done to finish the picture except work on the background and uniform. I can answer for its being a remarkably good picture, and as Fanny says, it is very like – Grant himself is particularly well pleased with his success.[54]

Finally, on 25 June 1843 Lord Minto wrote:

I went yesterday to see my portrait at Grant's. He was out, which I was sorry for – I cannot of course judge at all of the likeness, but should think it much younger than the original unfortunately is. However, others do not find this fault, so I suppose I am still quite a youth. As a picture it is decidedly very good, and will I am sure please you. It will be sent off to Leith immediately.[55]

It appears that a quality much admired in Grant's paintings was simplicity, a reflection of his own unaffected approach to portraiture. This is evident in his 1843 portrait of the 2nd Earl of Powis [PLATE 24], where the subject has a liveliness that immediately engages the interest of the viewer – his eyebrows drawn together, his grey hair brushed back, seeming to forget the paper which he is reading – an instinctive and immediate portrait, in which there is no trace of any kind of false grandeur.

Although taste now favours Grant's male portraits that was not the case in his lifetime, when he was principally admired for his 'most graceful and refined portraits' of women. A beautiful dress and a pretty face were significant ingredients in English portraiture of the eighteenth and nineteenth centuries. This view of Grant was remarked on by Benjamin Haydon in his diary for 1842:

Grant for a woman, Faulkner too, are not matched in any school in Europe, if they be, where? … Grant's lady is also purer than any of Lawrence's, something between Reynolds and Gainsborough … These two men [Grant and Faulkner] are surely worthy to paint any woman of fashion, let her be as beautiful as she may.[56]

Indeed, so much did Haydon see Grant as a painter of women that he was unduly scathing about his equestrian portrait of the Earl of Cardigan, where the insipid horse is virtually personified as a woman:

The Lord deliver me from the milk and water action of Lord Cardigan's horse … The horse is feeble in bone, blood, sinew, vigour and draw-

24. *Edward Herbert, 2nd Earl of Powis*, 1843
Powis Castle, The National Trust
(cat.no.36)

ing. It has never been bred in a stable but in a boudoir. It must have been groomed by a 'femme de chambre', and sent into the field for his Lordship, bedewed with otto of Rose and Eau de Cologne and pomade au jasmin. If Grant could give Lord Cardigan a little of his horse's timidity and engulf in the horse a portion of his Lordship's spirit, what a perfect combination then they would be![57]

These are not remarks, however, that could be applied to Grant's small oil sketch for the portrait [PLATE 25] which is full of excitement and fiery Venetian colour.

In his letter of 7 June 1842, Lord Minto had mentioned seeing in Grant's studio the portrait of *Louisa Stewart, 3rd Marchioness of Waterford* [PLATE 26], a portrait that was highly praised when it was exhibited at the Royal Academy. A critic's view of it shows how Grant's female portraits were judged at the time:

It exhibits the elegant taste of the artist as well as the beauty of the subject. The attitude is free, unconstrained and graceful, and there is a refined sweetness, mingled with intelligence in the expression which is quite captivating. This is in every respect one of the finest female portraits in the exhibition.[58]

Grant seems to have gone abroad only once, in 1844. The journey is recorded in a letter to Andrew Drummond of Cadland, in reply to a request to paint his daughters: 'Granby [Lord Granby, later the 6th Duke of Rutland] and I start for a tour through Holland and Belgium and Paris on Saturday September the 21st, and I shall probably be away for a month.'[59] He made a number of drawings in Amsterdam and Bruges but the journey had no visible effect on his work.

The small portrait which he painted on his return from the Continent of the Misses Drummond has many points of similarity to the rather earlier portrait of *Lady Prudhoe (the Duchess of Northumberland)* [PLATE 27]. Both portraits show how successfully Grant worked on a small scale. The Duchess sits *en plein air* beneath a tree, the landscape bathed in golden light in the pastoral style that Grant had derived from Gainsborough. Her hands

25. Sketch of *James Thomas Brudenell, 7th Earl of Cardigan*, 1841
National Portrait Gallery, London
(cat.no.50)

26. *Louisa Stewart, 3rd Marchioness of Waterford*
Private Collection

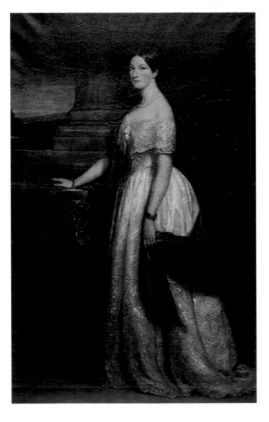

27. *Lady Prudhoe (the Duchess of Northumberland)*
Collection of the Duke of Northumberland, Alnwick Castle
(cat.no.29)

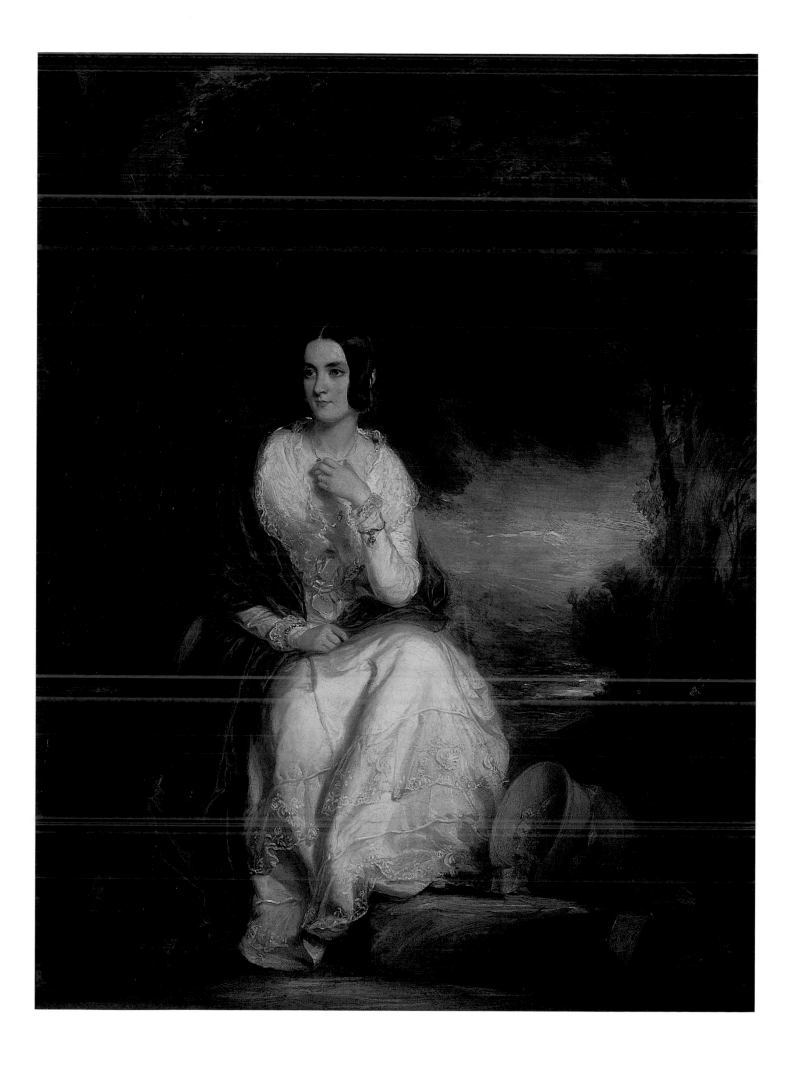

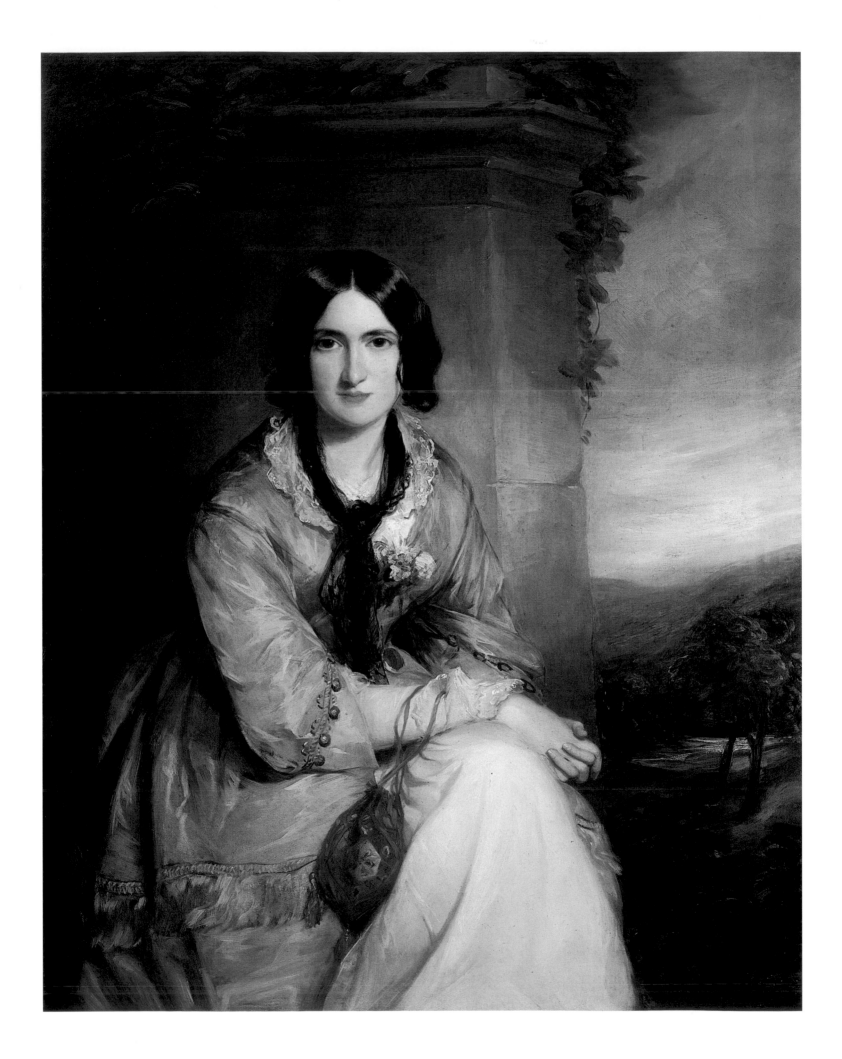

and face are treated in the finely detailed manner of Landseer, but the silk dress and cloak are painted with a much greater freedom.

The portrait of *Miss Singleton (Lady Rodney)* [PLATE 28], painted in 1844, was one of the four works which Grant sent to the *Exposition Universelle* in Paris in 1855 and one which was especially admired by the French critics. Half-length, Lady Rodney is seated in front of a stone wall very close to the picture plane. She wears a broadly, though lightly, painted mauve silk dress with flowers at her breast and a black scarf at her neck which matches both her black hair and her extraordinary, dark eyes. Her compelling presence and evident beauty were no doubt a great part of

the appeal of this portrait to mid-nineteenth-century audiences.

Although most of Grant's female portraits of the early 1840s refer back in various ways to seventeenth- and eighteenth-century precedents, one portrait seems to come from an entirely different context and is far more contemporary, even modern, in feeling. This is the portrait of Mrs Hope of Luffness which he painted in 1845. Wearing a loose black dress and a white lace collar through which her pink scarf is visible, she engages the viewer with haunting eyes. It is both the straightforward-ness of this gaze and the profound sense of her personality, as well as her completely unidealised beauty, which make this one of Grant's finest and most unusual works.

28. *Miss Singleton (Lady Rodney)*, 1844
Mr and Mrs Edward Harley (cat.no.30)

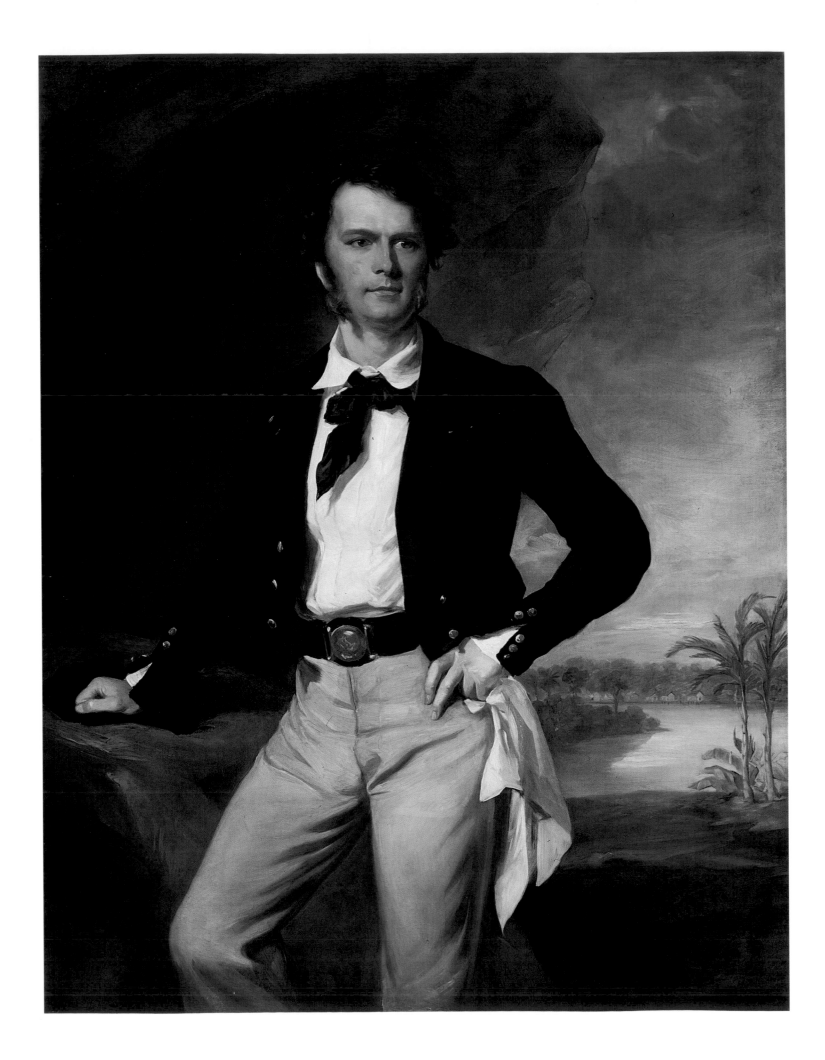

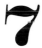

GRANT'S STUDIO AND PORTRAITS OF THE LATER 1840S

The extent to which Grant made use of assistants in his studio is not entirely clear. A copy of his sitters' book in the National Portrait Gallery in London was annotated by his daughter Elizabeth in 1898 at the end of the entries for 1842. She states that there was 'a criticism on this page [of the original book] saying that my father did not paint all of his pictures,[60] to which in his [ic, Grant's] handwriting is this added: "No portrait painter ever made less use of assistants than F. Grant."'[61]

Nevertheless, Grant seems to have employed at least two assistants, one called Paul and the other called Gooderson. Whether both of them carried out more than practical studio work, such as priming canvases, is not very clear, although Gooderson certainly made copies of some of Grant's portraits as early as 1841. Another recorded copyist of Grant's work was the landscape painter, Frederick Percy Graves, who may or may not have been a studio assistant. The copies were usually recorded as such in the sitters' book and the paintings signed by the copyist.

However, the evidence regarding second versions is somewhat contradictory. Although Grant liked to maintain that he did not copy his own work, there were several occasions when he did so. For example, Lady Middleton is recorded asking Grant, 'Do you ever copy your pictures? If so, will you copy the one of my mother [Matilda Bayard] for me?'[62] Grant's emphatic reply was, 'Never – but for you I will do so.'[63] The sitters' book makes it clear that he made this exception for several other clients.

Grant seems to be unique in the mid-nineteenth century in painting some of his sitters by gaslight. As has already been mentioned, Lord Minto had some evening sittings and in November 1845 James Stuart Wortley records the sittings of his fiancée, Jane Lawley: 'We *all* go at 9 o'clock for her first sitting, to Grant'.[64] The sitting was intended to last for one hour, so artificial light must have been used. This is confirmed by a recollection of Lady Dorothy Nevill:

Sir Francis Grant painted a picture of my sister and myself [in 1846]. This in my opinion was a great failure, for my sister looks like a murderess, while I am represented as apparently suffering from the effects of a narcotic which she has just administered. Sir Francis was an agreeable man and we often used to go to his house in Regent's Park to sit to him in the evenings. He was the only painter I ever heard of who painted by gas-light, a feat which has always lingered in my memory as a somewhat remarkable thing.[65]

There is also an interesting insight into how Grant organised his time and his approach to a formal portrait in a series of letters he wrote late in 1848 concerning a commission to paint Charles Longley, Bishop of Ripon (later Archbishop of York and then of Canterbury). Grant wrote the first of the series of letters to a decidedly impatient Bishop in early December, from Melton Mowbray:

I have left London for the winter months … When I return – it is not my custom to commence new pictures till the 10th April – as I occupy myself during the winter finishing pictures of the previous season … if it is not inconvenient I would rather delay the picture till the spring when the days are longer and the light more certain.[66]

Grant wrote again a week later:

I am very sorry it will not be in my power to accept of your kind invitation at the Palace, as I have been obliged to make a rule from which I have never deviated for very many years not to paint [away] from home. Moreover I may assure your Lordship I could not do so – without great detriment to the picture. In London I have three large rooms built on purpose with every variety of light capable of being accommodated to the nature of the day – beside several heavy pieces of painting room furniture which could not be provided without putting you to much trouble and inconvenience – all of which accessories are of essential importance to the success of a large full length portrait … I hope [you] will not find it very inconvenient to wait till May – which is the very best period of the year for commencing the undertaking.[67]

Later still, he wrote to the Bishop:

With regard to the time required to complete the picture – from the time of its commencement, I would undertake if required to deliver it in one month – but would prefer six weeks.[68]

Grant's last letter is dated 31 December.

I shall hold myself entirely at your command during the month of May – and I shall make a

29. *Sir James Brooke*, 1847
National Portrait Gallery, London
(cat.no.51)

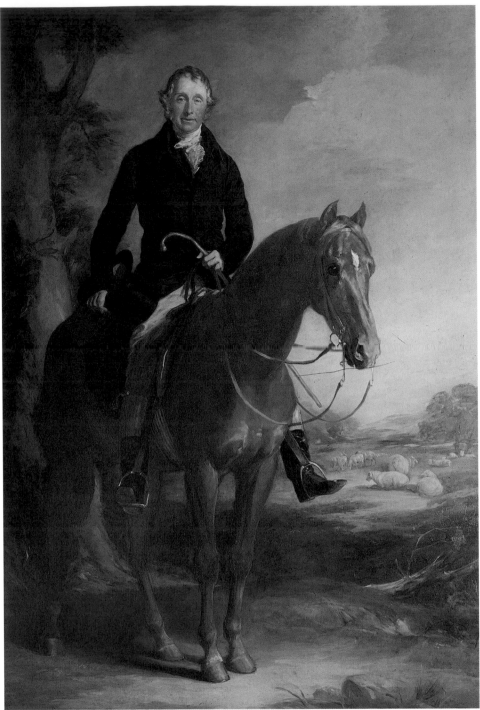

I look forward with the greatest interest to the picture – as the robes of a Bishop are the very best for a picture which modern costumes afford.[69]

In the second half of the 1840s Grant's most important works are usually portraits of men, exhibiting a great variety of types. The influence of Thomas Lawrence is evident in a number of these, for example, in that of Henry Charles Sturt, painted in 1849, which shows the sitter seated on a rock with romantically windswept hair. Sturt's arresting and intelligent face is treated with typically fine detail but much of the portrait is freely painted and the landscape background is suffused with golden light.

There are also a number of distinctive 'official' portraits, including three versions of a life-size portrait of Sir Henry Pottinger, soldier, diplomatist – and a friend of Grant's brother, Hope. The principal version was, according to the sitters' book, 'painted to be presented to the Emperor of China'. As can be seen from the surviving version, it was essentially a portrait of a man of action, the subject's expression alert and calculating. Another portrait of this type was that described in the sitters' book as 'George Hudson Esq, Railway King', who was Mayor of York on more than one occasion. The portrait is treated in the grand manner, but with an emphasis on colour and texture, and there is no attempt to show the portly magnate as other than a stately alderman.

Two of Grant's finest portraits also belong to this period – *Sir James Brooke* [PLATE 29] and *Sydney Herbert* [PLATE 31], both painted in 1847. Brooke was the Rajah of Sarawak and one of his personal aides was Charles Grant, second son of Francis Grant's brother, John, and therefore the painter's nephew. Brooke is informally dressed and stands casually in front of a background of water, palm trees and low houses, presumably an attempt to represent a scene in Sarawak. Henry Keppel refers to this portrait in his diary: 'Accompanied Brooke to Frank Grant's, who was painting his portrait – indeed a striking likeness – Grant the first artist in the country.'[70] The painting's spontaneity, directness and lack of pretension make it one of Grant's masterpieces.

30. *Sir Tatton Sykes, 4th Bt*, 1847
Private Collection (cat.no.38)

31. *Sydney Herbert, 1st Baron Herbert of Lea*, 1847
National Portrait Gallery, London

point of completing the picture according to your Lordship's desire by the last day of June … I am happy to say I do not think the picture would be any way benefited by much previous familiarity with the countenance – because in the early stages of a picture my time is occupied in modelling the masses of light and shadow. The two or three first sittings give me ample opportunity to become acquainted with the character and expression, which are the important consideration only of the very last sittings. The most difficult part of the picture will be the arrangement of the whole – as a composition –

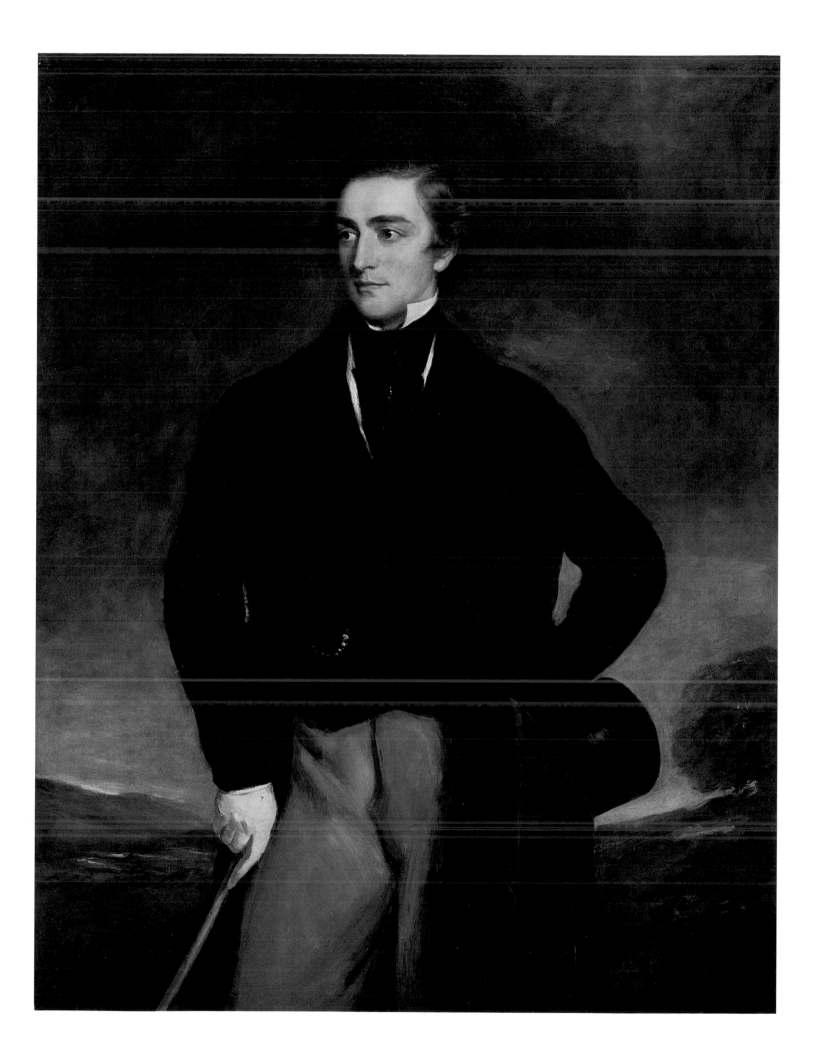

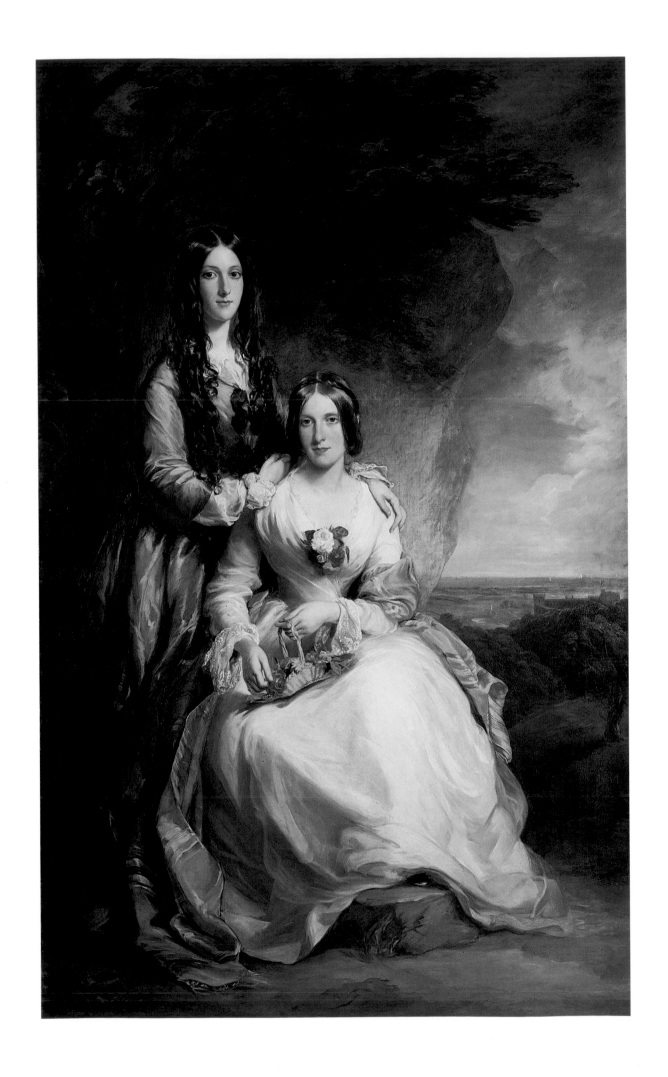

Sydney Herbert, one of the leading political figures of the age, also seems to have known Grant quite well. His portrait (there are two identical versions) has a quieter, subtler tone than the one of Brooke, the sitter pensive and introverted by comparison.

Another outstanding portrait of 1847 is the life-size equestrian portrait of the seventy-five-year old *Sir Tatton Sykes* [PLATE 30]. Sykes, a country squire, sits relaxed and motionless on his placid mount in a parkland setting. The picture's calm and seeming lack of movement are in stark contrast to the sense of dramatic action in some of the royal, military, and child equestrian portraits already discussed. Interestingly, Grant has here dropped his seventeenth- and eighteenth-century models and reverted to the more straightforward, unidealised manner of John Ferneley. Although Grant is now working on a much larger scale than Ferneley, the picture's lack of pretension is comparable to the latter's *Samuel Dumbleton in his Eighty-fifth Year* of 1835.

Grant's only multi-figured hunting picture of the 1840s was *The Cottesmore Hunt*, also known as *Sir Richard Sutton and his Hounds*. Although in some ways it looks back to his earlier hunt paintings, the scale is larger and the whole more broadly treated without the tentative quality of the earlier paintings. It contains portraits of fourteen mounted huntsmen and two on their feet, along with numerous hounds. Among Sutton's sons included in the painting is Henry Sutton on the extreme right of the group. There is a superb chalk study for this figure which illustrates the care which Grant put into his preparatory studies for such pictures.

The finest of Grant's female portraits of this period is the life-size double portrait of the two Howard sisters, Mary and Adeliza, daughters of the Duke of Norfolk [PLATE 32]. They are placed, one seated, the other standing, in the open air, with a view of Arundel Castle and the sea behind them, which does not relate very closely to the figures who are portrayed in a very direct way. The colour and light values of the painting are particularly marked and the decorative quality of their dresses is emphasised with a breadth and lightness of touch.

32. *The Ladies Mary and Adeliza Howard*, 1847
By permission of His Grace the Duke of Norfolk, Arundel Castle (cat.no.32)

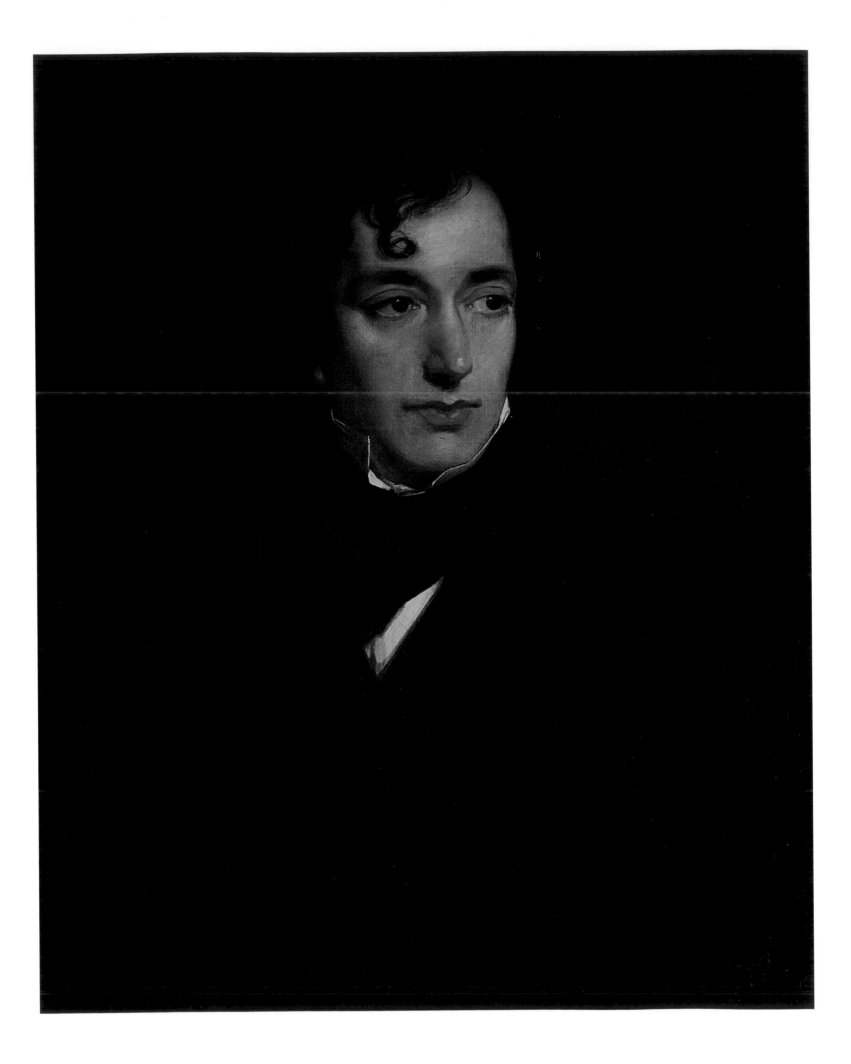

8

THE EARLY 1850S

By the early 1850s Grant's reputation as the foremost portrait painter of the day was firmly established, and his sitters began to include more and more leading politicians and public figures. He had been elected, partly through royal favour, an Associate member of the Royal Academy in 1842. Now, in 1851, he became a full Academician. Landseer wrote him a teasing, congratulatory letter: 'I said all I could to put the members on their guard. In spite of my observations about you and your fast character you were very pleasantly and honourably chosen.'[71] Grant once more started sending one, or occasionally two, pictures to the Royal Scottish Academy's annual exhibitions in Edinburgh. In 1855 he moved house from Sussex Villas to 27 Sussex Place, which was to remain his London residence for the rest of his life.

Among the major figures of the time who sat for Grant was Benjamin Disraeli whose bust-size portrait he painted in 1851 [PLATE 33]. It was probably intended as a gift as there is no record of payment. Disraeli is set against a featureless dark background with warm light focusing on his face. It is a work with some of the bravura of Lawrence but without his slickness, the sitter conceived as a kind of Byronic, romantic hero.

In 1853 Grant painted *Lord John Russell* [PLATE 44], later Earl Russell, son-in-law of Lord Minto and twice Prime Minister. He stands full-length, in front of an array of books, papers and dispatch case. The curves of the figure's broken silhouette and those of the tablecloth and chair give the picture a sense of dynamism and energy that matches the portrayal of personality. It was admired by the critics when exhibited at the Royal Academy in 1854, when *The Times* correspondent wrote in April:
Mr Grant's portraits are above the usual level of portrait excellence. 'Lord John Russell' and 'Mr Macaulay' are both perfect of their kind.[72]
He then noted in May:
Mr Grant's admirable portrait of Lord John Russell in the east room attracted universal attention, and his Lordship on his arrival [at the opening] received the congratulations, not only of his colleagues, but of his political opponents upon this spirited and characteristic likeness, the merits of which the noble Lord

appeared to take a pleasure in acknowledging.[73] At the Royal Academy dinner, Lord John Russell commented on the portraits of himself and Benjamin Disraeli: 'Both of us had the good fortune to have our resemblances painted, with very great success, by a man whose talent I honour and whose friendship I have had the happiness to enjoy.'[74]

The portrait of 'Mr Macaulay', that is, the historian Thomas Babington Macaulay, was less of a professed pleasure for its sitter. Macaulay was one of the few people who seem to have palpably disliked Grant. He did not suffer fools gladly, nor did he mince his words. Considering that he once described the Dean of Christ Church, Oxford, as a 'mere heavy taciturn sluggish pedant',[75] Grant escaped lightly. Grant was no intellectual and they had nothing in common, so Macaulay alleviated the necessity of having to converse with Grant by always taking one of his family with him to read or to chat during the sittings. These (seven in all) are briefly recorded over a six week period in May and June 1853:
To Grant's. Dearest 'B' came. She read two or three of Elia's essays. Grant is dull and a coxcomb, but a good painter.[76]
To Grant's. 'H' met me there and read and chatted during the session. Well that she did, for Grant would bore me to death. However, he paints good portraits.[77]
To Grant's through the rain. My teeth better, but still troublesome. Sat. Dear 'B' read some papers. … The last sitting, glad to have it done with.[78]
Much later, in 1877, Grant wrote of the oil study he had made for the portrait of Macaulay: 'The small picture is the original design for the life-size head painted for the late Speaker [Lord Ossington]. But I always thought this small picture the best likeness of the two.'[79] His study [PLATE 34] concentrates entirely on Macaulay's face. It is forceful and permits no illusions about the sitter. Macaulay's shaggy eyebrows fall almost over his eyes, his hair recedes untidily and his double chins bulge over his collar. It is a 'warts and all' portrait of a powerful personality and it is easy to believe that it is a profound likeness of the great man.

That Grant was now painting far more in terms of his own personality and depending much less on precedent, and was, indeed, at the height of his powers, is evident from two

33. *Benjamin Disraeli*, 1851
Hughenden Manor, The National Trust
(cat.no.53)

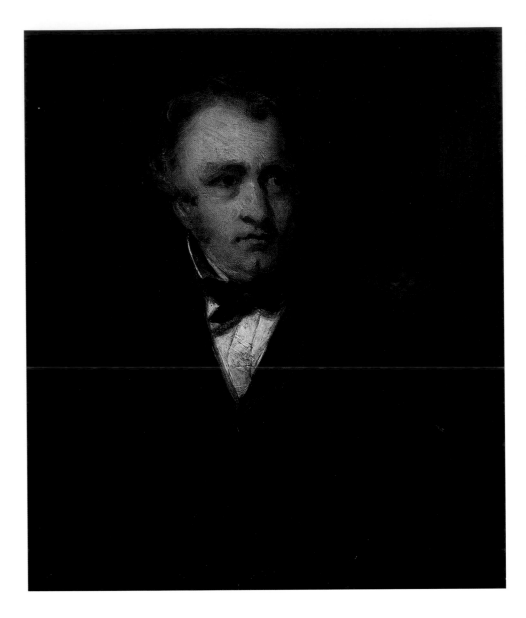

34. Sketch of *Thomas Babington Macaulay,
Baron Macaulay*, 1853
National Portrait Gallery, London (cat.no.56)

35. *William Henry Cavendish-Bentinck-
Scott, 4th Duke of Portland*, 1852
Private Collection (cat.no.40)

shows Sophia on her piebald pony, both her hair and the pony's tail flowing behind them. She holds the reins in one hand, and a child's riding crop in the other. The curve of her whip repeats the curling blue ribbon under her chin. The child's imperious glance seems to catch the viewer's momentary response, such is the natural feeling of movement and informality in the painting.

This sense of informality and immediacy is the dominant characteristic in the portraits of two of Grant's greatest friends, *Walter Little Gilmour*, probably painted in 1850 and *Sir Edwin Landseer* [PLATE 39], painted in 1852 and exhibited at the Royal Academy in 1855. Gilmour, shown in three-quarter length, stands with a slightly wistful expression before a view of the River Tweed. The portrait of Landseer is equally sensitive. In black, he stands in front of a completely plain background, so that nothing distracts from his encounter with the viewer through his slightly narrowed eyes. (The dog beside him was painted by Landseer himself.)

It was during this phase of his career that Grant painted what might be regarded as his masterpiece, the portrait of *The Duke of Portland* [PLATE 35] of 1852 (exhibited at the Royal Academy in 1853), 'presented to the sitter by nearly 800 of his tenants'. John Evelyn Denison, later Lord Ossington, the Duke's son-in-law, mentions the work in a letter of 1852:

We came over yesterday to meet Frank Grant. I took care to set before him and before the Duke the general wish of the tenants about the leathers. Grant has made a capital sketch this morning of the Duke in his leathers, boots and blue coat, a very successful sketch indeed. It is the very man the neighbours have seen for so many years, riding about among them.[80]
The Duke was eighty-four years old at the time. He sits rather heavily and a little hunched in his green leather and mahogany chair, in front of his much loved park at Welbeck where he had spent so many years planting trees. His figure has an extraordinarily compelling presence, as Denison's letter suggests.

Throughout his career Grant painted a number of portraits of husband and wife, but more often than not they were painted at

portraits of children painted at the beginning of this decade. One of these is of the schoolboy *The Hon. Francis Byng* [PLATE 37] which was framed together with the portrait of *Master George Byng* [PLATE 36] painted eight years earlier. The contrast is remarkable – the earlier portrait contrived in an eighteenth-century manner, while the portrait of Francis is spontaneous and direct. Indeed, the immediacy of the depiction of the eighteen-year old Etonian, in his school rowing clothes, his legs crossed carelessly, is surprisingly modern in feeling.

The other remarkable child portrait of this time is that of *Lady Sophia Pelham on her Pony* [PLATE 38]. Painted in 1852, it was exhibited at the Royal Academy the following year, and again in 1866 when Grant became President of the Academy. This, the most celebrated of Grant's portraits of children,

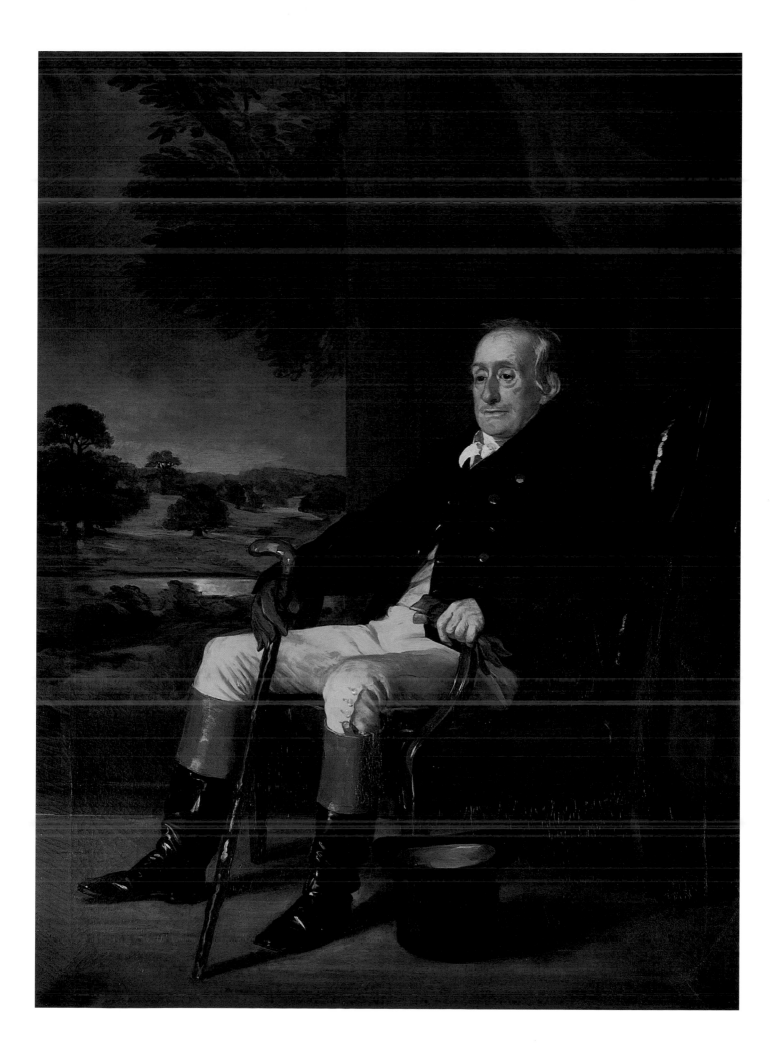

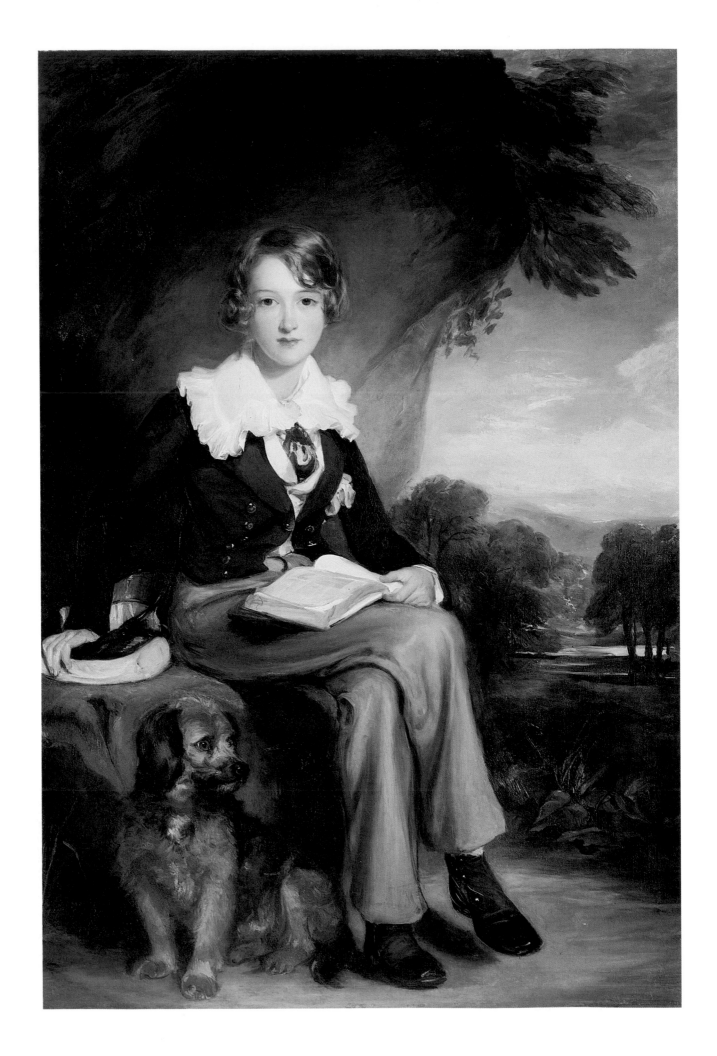

36. *Master George Byng*, 1843
Private Collection

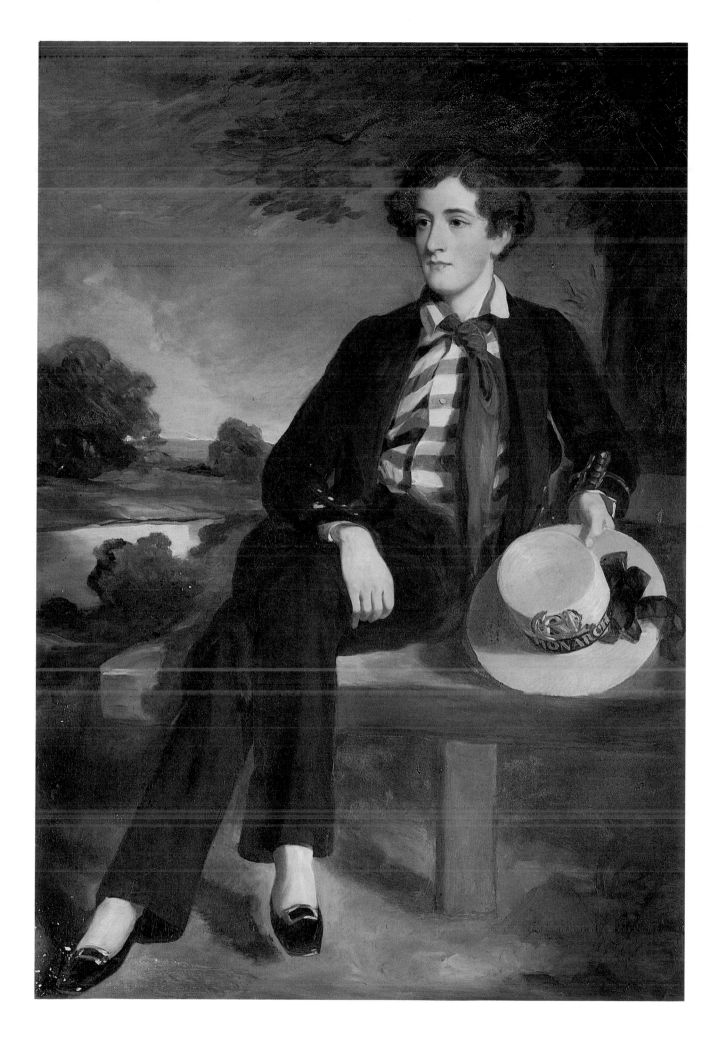

37. *The Hon.*
Francis Byng, 1851
Private Collection

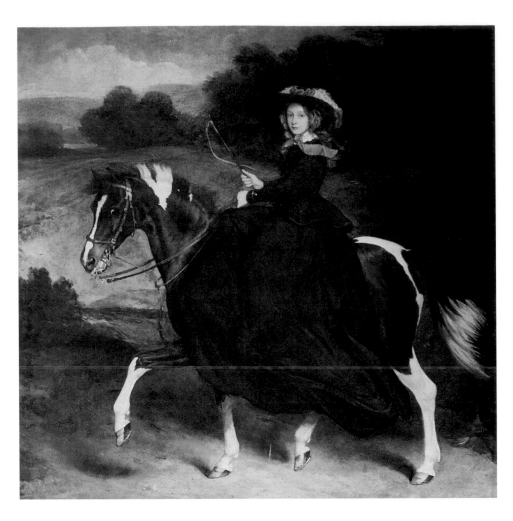

38. *Lady Sophia Pelham on her Pony*
Private Collection

Enfield it departs from Grant's normal approach to female portraiture at this time. Mary Isabella sits in a lightly painted, rather colourless landscape absorbed in her knitting. Her face is in profile and ivory smooth in treatment. On her lap lies her blue and white striped knitting, and an orange, green, black, white and gold striped bag. The painting as a whole, despite these decorative elements, has a domestic feeling. Mary Isabella subsequently married William Geary in 1852 but sadly died in 1854. The painting was presented to the Royal Academy as Grant's diploma work but was later withdrawn. There are two possible reasons for this. It may have been because the painting came to be seen as a portrait rather than a genre scene – and portraits were not acceptable as diploma pieces. A more likely explanation, however, is that because of Isabella's untimely death the family simply wished to retain the portrait.

There are two other female portraits of high quality from the first half of the 1850s – *The Countess of Kintore* of 1851 and *Mrs Chafy in her Bridal Dress* [PLATE 43], painted in 1853. The former, which is very freely handled and based on the composition of the *Louisa Stewart* of 1844 [PLATE 26] came to be regarded after Grant's death as one of his finest portraits of women. The portrait of Mrs Chafy continues Grant's progress towards a simpler, less idealised manner. It has an immediacy and straightforward simplicity that sets it apart from most Victorian female portraits of the time.

different dates and were not conceived as matching pairs. However, two couples that were painted as pairs were the portraits of Lord and Lady Enfield (later Earl and Countess of Strafford) and Mr and Mrs John Naylor [PLATES 40 & 41]. Lord Enfield is shown as if walking in his country estate, contemplative and melancholy. John Naylor, a Liverpool banker and picture collector, is set in a rather grander landscape, leaning against a stone pedestal. His expression is pensive and brooding.

Lady Enfield's portrait, like that of her husband is soberly coloured, except that she wears a brilliant scarlet stole over her black dress. She is painted with a degree of unidealised realism which is surprisingly modern in effect. Mrs Naylor's portrait also relies on the impact of a bright red shawl contrasting with a black dress, in this case worn over her left shoulder and around her waist.

Grant's outstanding female portrait of the first half of the 1850s is that of his daughter, *Mary Isabella Grant* [PLATE 42]. Like *Lady*

39. *Sir Edwin Landseer*, 1852
National Portrait Gallery, London
(cat.no.54)

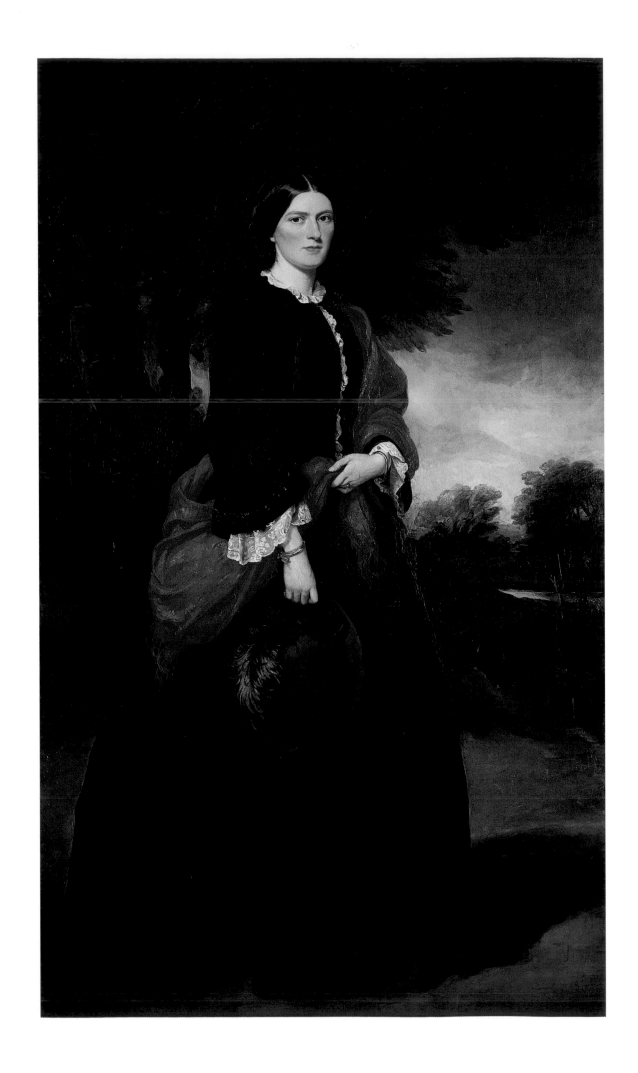

40. *Mrs Naylor*, 1857
National Museums Liverpool
(cat.no.34)

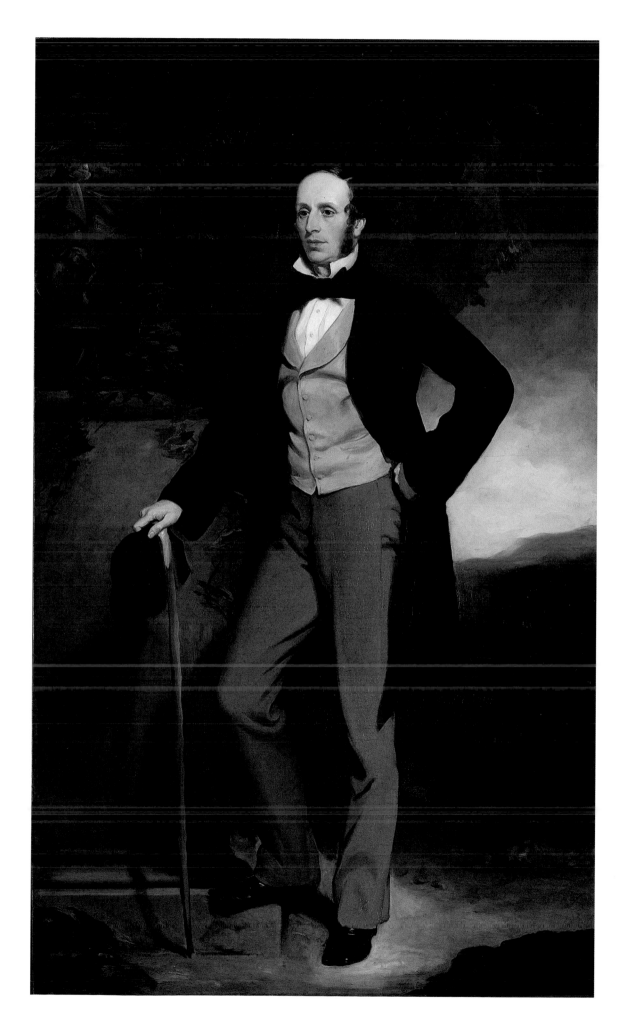

41. *John Naylor*, 1857
National Museums Liverpool
(cat.no.41)

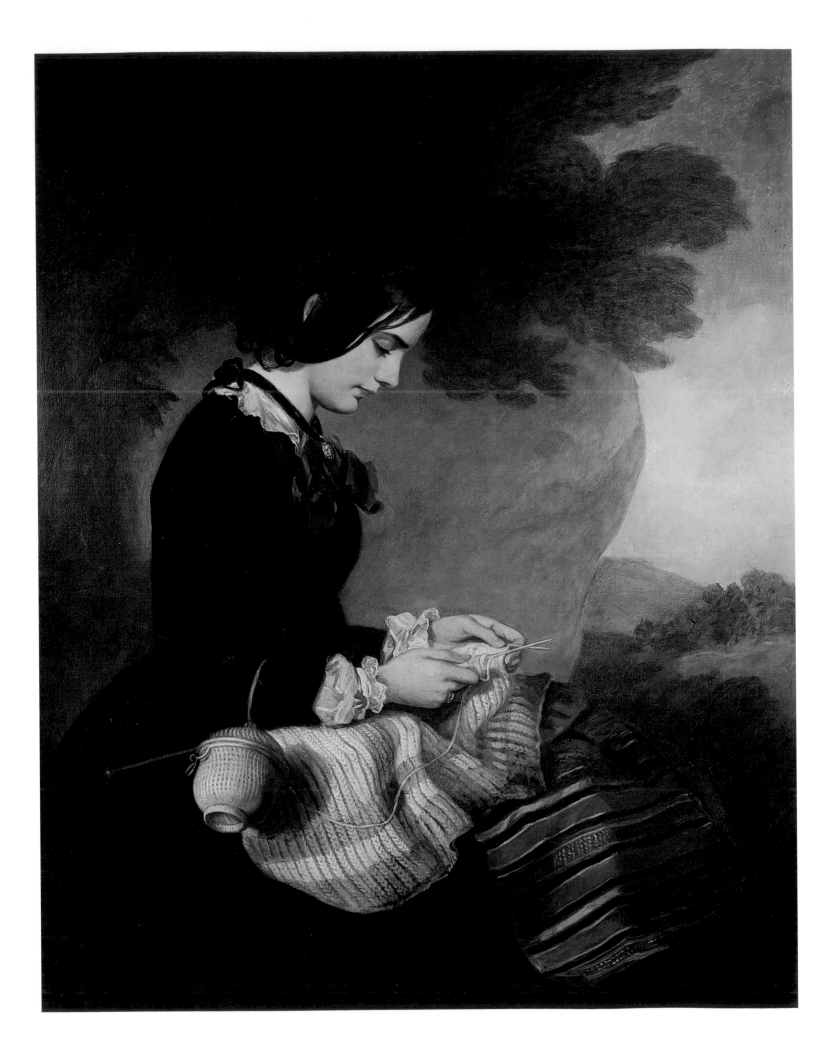

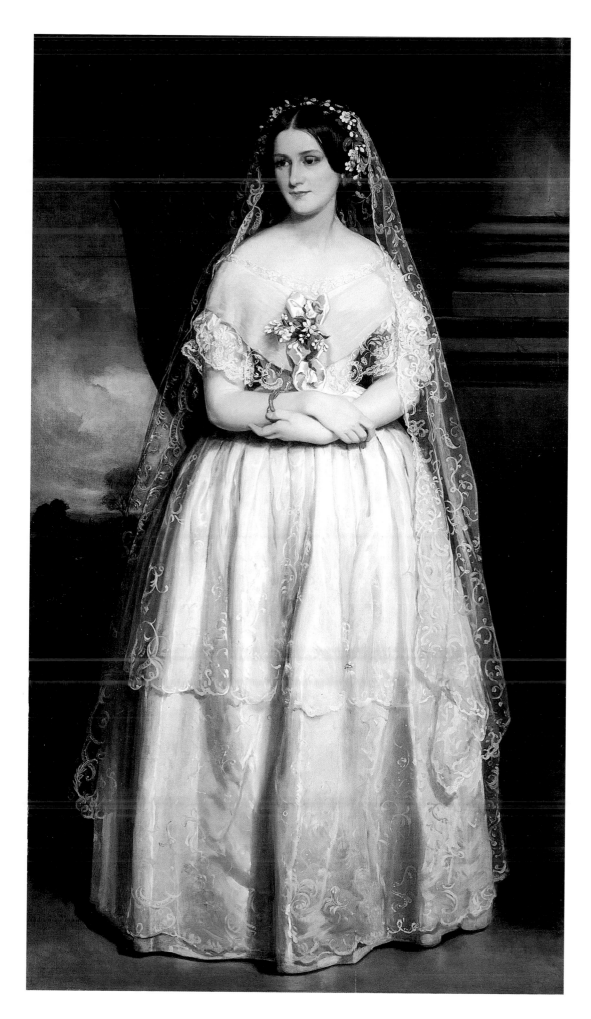

42. *Mary Isabella Grant,* c.1854
Private Collection (cat.no.13)

43. *Mrs Chafy in her Bridal Dress,* 1853
Mr James Swartz (cat.no.33)

9

THE 1855 PARIS EXPOSITION UNIVERSELLE

In 1855 Grant sent four paintings to the *Exposition Universelle* in Paris. Although there had been much enthusiasm for British painting in France in the early decades of the nineteenth-century, for nearly thirty years preceding the exhibition of 1855 there had been few opportunities for seeing British paintings in Paris. Consequently, the re-appearance of contemporary British art aroused a great deal of interest. It is perhaps a little odd that, having painted so many portraits of high quality in the early 1850s, Grant chose to send only one of them, the *Lord John Russell* of 1853 [PLATE 44]. The other paintings exhibited were the *Lady Rodney* of 1844 [PLATE 28], the *Lady Beauclerk* of 1840 and *The Ascot Hunt* [PLATE 9] painted as long ago as 1835. In the event, although the portraits were admired, it was the hunt picture that captured the French imagination.

Grant's sister-in-law, Lady Lucy Grant, wife of John Grant and daughter of the 7th Earl of Elgin (who had once lent Grant paintings to copy) was in Paris for the opening of the exhibition. In her journal for 1855 she emphasises the importance of the occasion, but does not record her brother-in-law, Francis, as being present. She writes, rather excitedly:

The day the exhibition opens. The Emperor and Empress to be there, in full dress, and the Court, and all who sit in the front places – 50 francs a ticket!![81]

June 2nd. I went to the 'Beaux Arts'. A wonderful suite of rooms. The Belgian Collection of paintings seems the finest – then the British. Frank Grant's give great satisfaction, though he does not consider them his best there is to my mind an exquisite softness and poetry about them. Landseer's are charming. I do admire his animals. Frank Grant has four pictures – his portraits are really beautiful – his females so feminine, so full of poetry, his hunting picture very full of merit, the subject being so difficult … Landseer oh how I do admire his! but the French are disappointed, they think the engravings superior, that they want in colour and pictorial effect![82]

Grant was awarded one of ten *Médallions de Première Classe* which, in spite of being a gold medal, was actually the equivalent of a third prize. Landseer, however, received a *Grande Médaille d'Honneur*, an award of a higher degree.

In his journal the great French painter Eugène Delacroix devoted some time to considering why he liked the English paintings displayed in Paris so much. He wrote in June 1855:

[In translation] I am conscious … of the special charm of the English school … the little that I have seen has stuck in my memory … I don't see here [ie in France] anything that can compare with Leslie, Grant, with all those of this school who derive partly from Wilkie, partly from Hogarth, with a little of the the fluidity and the ease introduced into this school in the past forty years by the Lawrences and their followers who were distinguished by their excellence and lightness of touch.[83]

Also in June 1855, a writer in *Le Moniteur Universel* wrote of

… something rare today in the English School, M. Grant continues the Lawrence tradition. … The two female portraits of M. Grant – Lady Beauclerk and Lady Rodney, recall the portraits of this master, of whose aristocratic elegance, free touch and poetic arrangements they partake – The portrait of Lord John Russell is also an excellent work.[84]

The Symbolist poet and critic, Charles Baudelaire, saw Grant differently, however. He wrote in his *Salon de 1859*: 'I was looking forward to renewing my acquaintance … with Grant, the natural heir of Reynolds.'[85]

44. *Lord John Russell*, 1853
National Portrait Gallery, London
(cat.no.55)

10

PORTRAITS OF THE LATER 1850S AND EARLY 1860S

From the middle of the 1850s Grant's works show a certain coarsening of style and the quality is much more variable. He also painted a number of works of great size, possibly because an increasing number of his portraits were presentation pieces, often given by tenantry, neighbours or members of a hunt who probably equated size with excellence. Some were also painted for vast houses with very large rooms. In 1860 *Fraser's Magazine*, when reviewing the Royal Academy exhibition, complained, with a touch of humour, of the huge size of some of the portraits, and particularly Grant's *First Note in Cover* (the first time the artist had used a descriptive title of this sort):

The principal figure [a hunter] and his rider [are] unconscious of everything except that they are in Trafalgar Square and staring down upon very respectable company. Against the painting of this work of art we have not a word to say. Indeed so vigorous and bold is the treatment it might be hung, we believe, over the gate of Northumberland House and studied from the steps of the Academy. That is, if the day were clear ... Almost as much might be said for ... several others, whose vast proportions favour the supposition that the poverty of invention displayed by the paper stainers of England is such that persons about to furnish are anxious to cover up the walls of their houses upon any terms.[86]

A significant number of Grant's portraits continued to be of men who were of particular political prominence. Most notable among these was Edward Stanley, Lord Derby, who was to be three times Prime Minister (and who owned a famous stud). Grant painted him in 1858. The oil study for the portrait is evidence that the painter had caught the dynamic energy of the subject and his lively spirit is emphasised almost to the point of caricature. When the full-length portrait itself was engraved in 1860 (as were a high proportion of his later portraits), Grant wrote of his concern about the print's accuracy to the engraver: 'With regard to the face I find the eyes have not sufficient importance and the nose a great deal too much importance – Lord Derby's nose is short but aquiline.'[87] He then added two sketches to his letter – a correct rendering of Lord Derby's features and one showing the

exaggerated nose and the less than compelling eyes.

Another outstanding portrait of a major public figure is that of Lord Palmerston which Grant painted in 1862 for presentation to Harrow School library by old Harrovians. Palmerston probably had difficulty in finding time to give Grant sittings, as these were spread over a six-month period. Grant wrote to an unknown correspondent: 'I am obliged to you for sending Carrington. He can't fill Palmerston's coat, which hangs in drapery about the ribs – but he will be useful for the hands.'[88] It seems surprising that, at the same time as requiring authentic details such as Palmerston's own coat, Grant was prepared to include another man's hands. In fact, the lighting of the portrait emphasises the hands as well as the face and white shirt front, the whole painted with great bravura.

From the same year is Grant's portrait of Lord Middleton, which has the particular interest of having been painted in direct competition with Queen Victoria's favourite painter, Winterhalter. When Lord Middleton's tenants decided to present him with portraits of himself and his wife, Lady Middleton chose to have Winterhalter paint her and travelled to Paris, where the painter resided. Lord Middleton remained behind in London to be painted by Grant. Winterhalter's portrait is slightly bigger than Grant's and depicts the formidable Lady Middleton in a large and opulent dress. Lord Middleton's superbly painted state robes can hardly compete with this but a comparison of the two paintings illustrates how much more successful Grant was in his ability to portray character and personality.

Grant portrayed man and wife together, both on horseback, in his vast presentation portrait of *The 8th Duke of Beaufort and the Duchess of Beaufort*, painted in 1863 for Badminton. By this time the earlier ducal portraits in the house by Lely, Reynolds, Hoppner and Lawrence were of little significance to Grant. The picture is marked by its realism and lack of ostentation. The Duke is characterised as a bluff country gentleman, seated on an unglamorous grey horse, his wife beside him on a more elegant mount, and accompanied by two favourite hounds

45. *Mrs Markham,* 1857
Private Collection (cat.no.14)

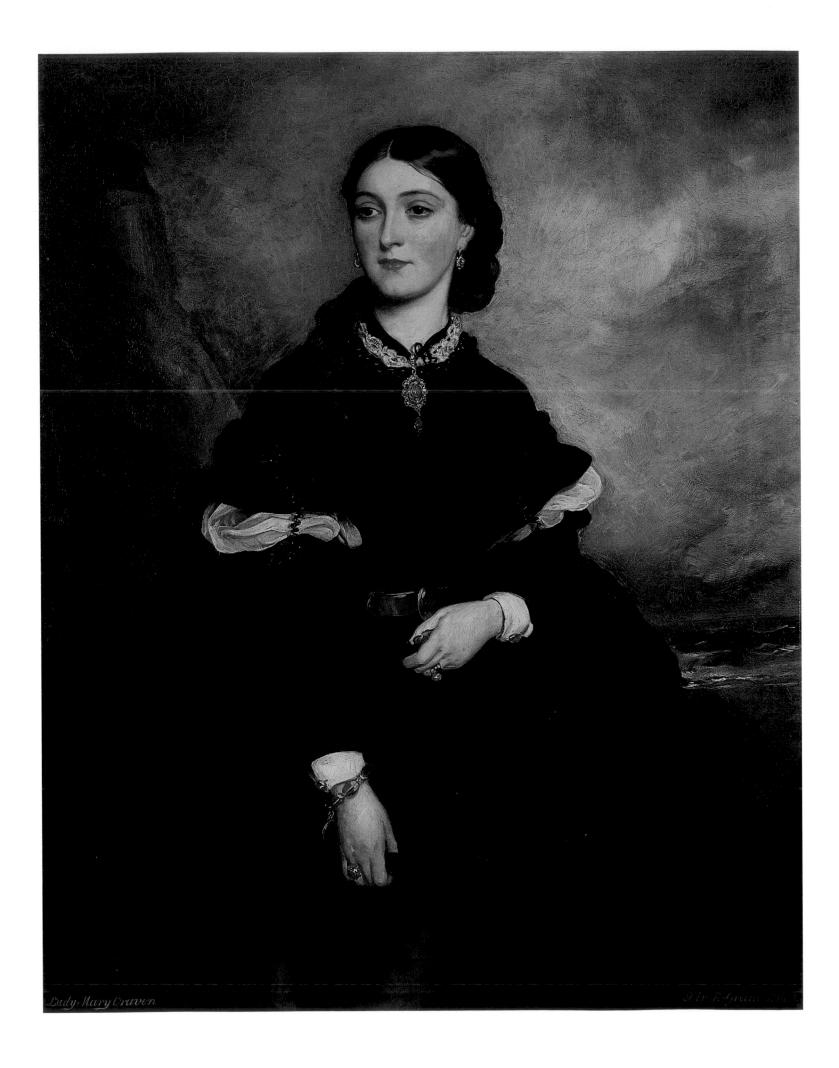

Lady Mary Craven Sir F. Grant

depicted with straightforward accuracy.

Although portraits of male aristocrats, some of them major figures in public life, predominate in Grant's oeuvre at this time, he also produced a number of female portraits that are marked by a similar direct realism, although overtly decorative as well. These include a full-length of his daughter Anne (always called Daisy), *Mrs Markham* [PLATE 45], painted in 1857, of which the brothers Richard and Samuel Redgrave wrote: 'one of his portraits of most marked excellence is that of his daughter … in a walking dress looped over a brilliant red petticoat'.[89] She stands full face in a snowy landscape, pulling on her gloves. The portrait has a natural directness and also uses the device of black lit up by a smaller area of red, something Grant had done in his earlier portraits of Lady Enfield and Mrs Naylor.

Of an equal naturalness, and once more using the red against black theme, is the portrait of *Lady Mary Craven* [PLATE 46] of 1861. The subject stands by the sea and looks beyond the viewer. She wears black and white lace and holds a black cloak and a black hat, the hat's blackness interrupted by a splash of red feathers.

In 1864 Grant painted one of his most outstanding female equestrian portraits, *Mrs Brassey with a Horse and Dogs* [PLATE 47], a painting which he must have regarded highly himself, for he sent it to the *Exposition Universelle* in Paris in 1867. Surprisingly, it owes much to the sentiment of Landseer – and perhaps he felt this might appeal to a French audience. Although the action of the horse, lowering its head towards the dogs, and the pose of Mrs Brassey may owe something to Reynolds's *Captain Robert Orme*, both the horse and the dogs are painted with a Landseer-like virtuosity. Indeed, the immense, dignified deerhound and the small bounding terrier are a variation on the theme of Landseeer's *Dignity and Impudence*. Mrs Brassey herself, simply dressed, stands beside the horse, natural and unaffected.

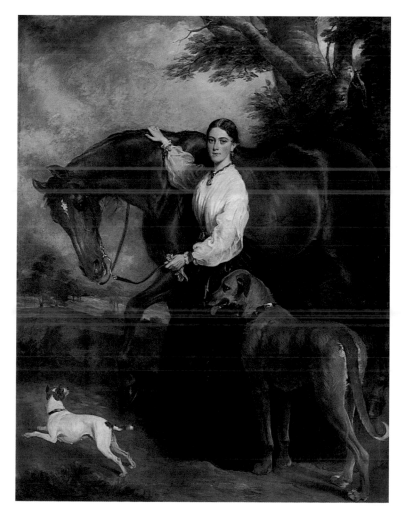

46. *Lady Mary Craven*, 1861
Collection of the Duke of Northumberland, Alnwick Castle (cat.no.35)

47. *Mrs Brassey with a Horse and Dogs*
Hastings Borough Council

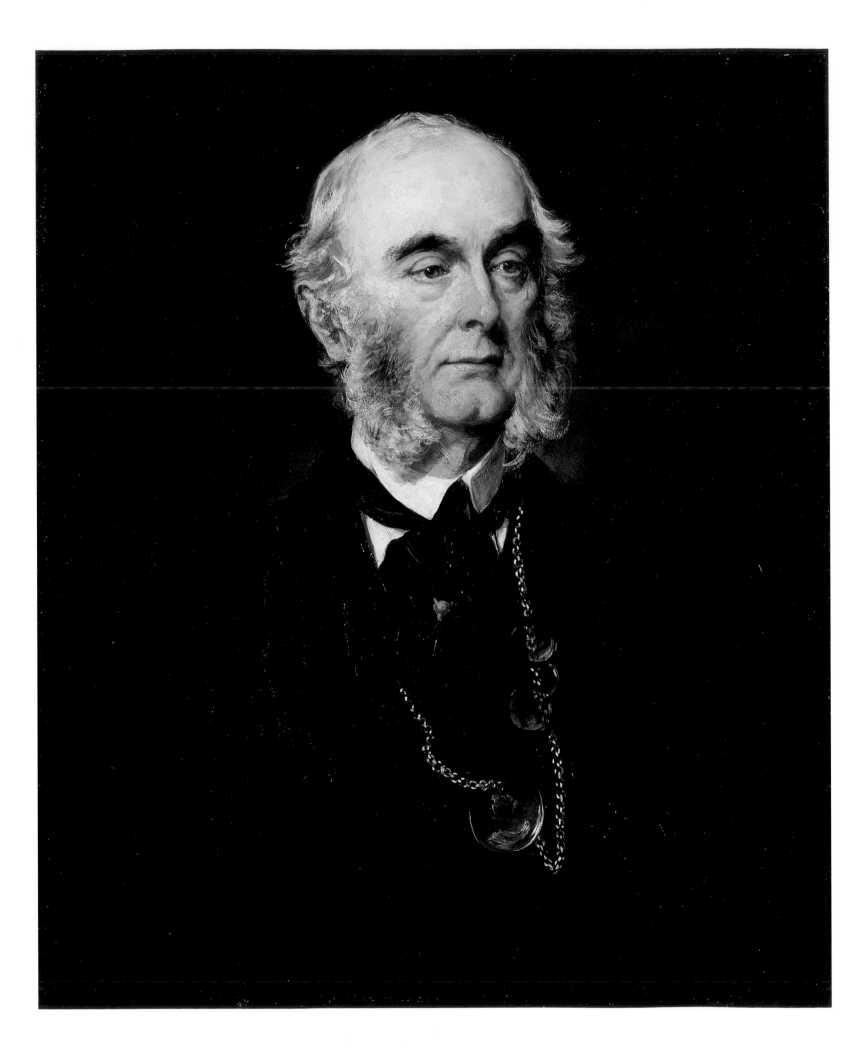

11

PRESIDENT OF THE ROYAL ACADEMY

On 24 December 1865 Sir Charles Eastlake, President of the Royal Academy, died in Italy. One month later, Sir Edwin Landseer (who had been knighted in 1850) was elected by a large majority to succeed him, but refused to serve, proposing Grant in his place. At a second vote on 1 February 1866, Grant was almost unanimously elected as President. The *Illustrated London News*, in an article in March 1866, evidently considered Grant to be an improvement on Eastlake:

It must be, so far, an advantage to have at the head of the profession not only an able painter, but a thoroughly manly, honest and courteous British gentleman ... our most fashionable portrait painter since Lawrence.[90]

Queen Victoria, on the other hand, in a letter of 19 February 1866, to the Prime Minister, Lord Russell, commented disparagingly on Grant's appointment:

The Queen will knight Mr Grant when she is at Windsor. She cannot say she thinks his selection a good one for Art. He boasts of never having been to Italy or studied the old masters. He has decidedly much talent, but it is the talent of an amateur.[91]

Lord Russell, Disraeli and Lord Derby (who would succeed Lord Russell as Prime Minister in June 1866), all wrote Grant elegant congratulatory letters.

Richard Redgrave gives a delightful account of Grant taking the chair for the first time at the annual Royal Academy dinner in May 1866:

Today our new President ... took the Chair ... on Thursday last, while showing the Prince of Wales round the rooms, the Prince asked him if he felt at all nervous at the prospect of his new duties at the dinner. Grant replied 'Not at all. But then', he added, 'I am perhaps in the same condition as the Captain who went up in a balloon and was to descend by parachute, after quitting the car in the air, his fellow voyager called out, just before he cut him loose, "All right below? Do you feel at all nervous?" "Not at all" replied the Captain, "Cast off" and, said Grant, 'down he came and the next moment was smashed up. Now that may be the case with me' ... But tonight the result was quite reversed, for the President was a great success. He had four Princes at his table to grace his debut, and he did all his speechifying extremely

well, even after Eastlake, for what it lost in calm impressiveness, it gained in geniality. The fox-hunter came out and made one or two good hits. Altogether I am agreeably surprised at our having landed on our feet in this matter.[92]

Grant's immediate task on becoming President was to find a satisfactory solution to the complicated problem of rehousing the Royal Academy. Founded in 1768 in Pall Mall, it moved in 1775 to Somerset House. It left there in 1836 to occupy part of Wilkin's National Gallery building in Trafalgar Square. As early as 1845 it was acknowledged that there was insufficient space for both institutions and Eastlake was urging separation, but nothing was done. In 1850 Lord Russell, then Prime Minister, said that the 'apartments now occupied by the Royal Academy would be required for the purposes of the National Gallery'.[93]

Nothing happened during Eastlake's presidency and by the time that Grant took over at the beginning of 1866, matters had come to a head. Neither institution wanted to move, but the government decided that, as the National Gallery had been the first occupant of the building in Trafalgar Square, it was up to the Royal Academy to leave.

It was Queen Victoria's view that the Royal Academy should buy a site in Kensington Gore and build there from scratch so as to become a part of the Kensington building project that was to be a memorial to Prince Albert who had died in 1861. This was a view supported by Lord Derby, who was currently Prime Minister. However, there were strong objections from the Academy, both to the expense of building at Kensington and to the remoteness of the area. Kensington in the 1860s was still virtually a separate village. As the Academy relied on the summer exhibition for two-thirds of its annual income, it was thought essential that its location should be central. The only alternative proposed was the south front of Burlington House, but this was much too small. Grant, therefore, had a considerable problem on his hands, which he nevertheless managed to solve by late August.

Grant had first negotiated with Lord Russell's government and there is a series of letters from Grant to the Hon. William Cowper, First Commissioner of Works from

48. *Self-portrait*, 1876
Royal Academy of Arts, London
(cat.no.6)

1860 to 1866. Cowper was succeeded by Lord John Manners (a younger brother of the 6th Duke of Rutland, already well known to Grant), when Lord Derby's government took over in June. Grant thus had to begin negotiations all over again but he continued to use the same arguments with Lord Manners. All of Grant's letters are polite, elegant and tactful – but firm. He was particularly worried about finances, as he had written to Cowper on 23 April 1866:

If the R.A. has to build a new building from scratch, it will inevitably exhaust the available funds of the Academy, leaving us unable to meet the expenses of our pension list and charitable donations, or to carry on the important and national object of the Institution in the teaching of our schools. I beg to remind you that we have the written guarantee of the Chancellor of the Exchequer that in the event of our being required to vacate our present building in Trafalgar Square, he under-takes to provide an equivalent elsewhere. Now, in the transactions of ordinary life, if you were to turn a man out of his comfortable and well furnished house, it could hardly be considered an equivalent to offer him another piece of ground on which he was to build a house and furnish it at his own cost.[94]

Grant continued by saying that 'the Royal Academy really was entitled to receive a building from the Government, but of course the Royal Academy would be happy to spend as much as they could possibly afford on it.'[95]

At this point, in fact, Grant was still intent on trying to remain in Trafalgar Square, and hoped that the National Gallery would be sent to Burlington House. However, when the government changed, Grant realised that he had no hope of achieving this. Grant then suggested alternatives on the Burlington estate. Sidney Smirke, who had been the Royal Academy's Professor of Architecture, and was now treasurer, drew up some plans, which were sent to Lord John Manners, who approved them and sent them on to Lord Derby. The plans showed that the Royal Academy would occupy Burlington House and build on the ground immediately to the north. Grant apologised for disappointing the Queen and Lord Derby by not having chosen South Kensington but stated that the members of the Academy

have no doubt that the Burlington House site as proposed, occupying an important central situation, would be more advantageous for the Academy … As they would have a perfect architectural front in Burlington House the expense of building would be comparatively small.[96]

The end result was that the government granted the Royal Academy a lease on Burlington House and the ground behind for £1 per annum for 999 years, providing that the Academy paid for all the building works, which included adding a new top floor to Burlington House.

In letters between Grant and William Gladstone, Grant gives the statesman much credit for insisting that Burlington House was the right location for the Royal Academy and that a site should somehow be found there. It was natural that Gladstone should have been concerned with Burlington House's fate, for it was while he was Chancellor of the Exchequer in 1854 that he had recommended that it should be bought by the government. Since then, there had been much inconclusive discussion as to its prospective use. Grant now showed design proposals drawn up by the firm of Banks and Barry for the buildings to Gladstone and the government architects took note of Gladstone's suggestion of raising the height of the main entrance arch.

In September 1866 Grant received a congratulatory letter from Landseer in France:

I have been very highly gratified by intelligence new from my brother [Charles Landseer] … you have every right to be pleased with yourself, and the vote of thanks is but a poor acknowledgement of the lasting service you have been to the Institution. In a few months you have achieved more than our lamented friend Sir C.L.E. [Eastlake] did by years of caution and wary watchfulness and wise meditation – as one of your oldest friends accept my thanks and congratulations.[97]

Having solved the question of the location of the Royal Academy, Grant's problems had, in fact, only just begun. It is not ideal to have three different architects responsible for three related constructions on the same site, and all active simultaneously, as was the case at Burlington House. James Pennethorne, architect to the Office of Works, was to design

the buildings required for London University, while Sidney Smirke was to alter, and add a third storey to Burlington House itself for the Royal Academy. Banks and Barry, working for the government, were to design the wings and new south front of Burlington House to accommodate the six so-called 'Learned Societies', three of which were housed in old Burlington House. The south part of their site fronted Piccadilly, so their design had to include the main entrance into the courtyard in the form of a grand archway to allow access to the Royal Academy. Whereas Smirke's designs only needed royal and Royal Academy approval those of Banks and Barry needed the sanction of parliament as well.

A series of letters from Grant to Banks and Barry, starting in 1866, show how, although initially amiable towards them, he became more and more exasperated by their delays and inefficiency. He was also frustrated by the complications of organising and synchronising so many different people and interests, as well as gaining approval from so many diverse bodies. Grant wrote crossly in one letter that 'red tape was supreme in the faculty of doing nothing'.[98]

Like Gladstone, Grant was also concerned with the size of the archway of the main entrance, which he and others thought too small:

I think the narrowness of the archway – only eighteen feet is inadmissible – the public – especially the gentry and nobility would complain of the dangerous access and egress; it would be a very narrow entrance which would make the ladies and the gentlemen very nervous.[99]

He added a drawing of his own suggestion for the archway.

There was huge public interest in the projected plans for Burlington House, as shown during 1867 by articles in the *Illustrated London News* and *The Times*. There was also much outside interference: one MP, for example, persistently advocated red granite pillars on the Piccadilly façade, while Grant wrote that he had 'heard all sorts of rumours, that one side of the quadrangle was to be medieaval [*sic*] and the other side Grecian'.[100]

Grant had to take Banks and Barry's drawings to the Queen for her approval, which in due course he received, but he also sent a warning to the architects about parliament's approval:

The more I look at the painted large drawing of the archway with the lady in the green petticoat, the less I like it – I advise you not to send it to the House of Commons – it will turn the whole thing into ridicule.[101]

Having shown the drawings to the Queen, Grant wrote again to the architects:

I presume you have received the drawings. You will see I have got the Queen's signature to the Royal Academy which I hope will be useful in the House of Commons. I have taken a liberty with you and Mr Barry, having toned down the green petticoat and the pink petticoat and the green parasol – also subdued the white blinds, the jet black windows, and with a little water made the shaddows [sic] in B. House more tender … I think the drawing looks now sufficiently respectable.[102]

In a further letter to Banks and Barry, Grant notes:

I have no copies of the photographs of any of the buildings – the originals may I suppose be now removed from the House of Commons … I should advise you to affect this for when people look too long at anything they tire and find fault and they have successfully done their work. The photographs you sent me I put in a handsome portfolio and left them with the Queen not to be returned.[103]

Once building work started, Grant increasingly lost patience with Banks and Barry. In December 1869 he complained of the 'chaos' and 'confusion' that they had created in the quadrangle, which was preventing Smirke's work from starting and he had to ask the head of the Office of Works to remove Banks and Barry's office together with some sheds in which fires were being burnt as this was a serious risk to old Burlington House. Grant complained that they were carrying out work there which had 'nothing to do with the buildings of the Learned Societies', but which '… are for a circus for a Mr Cook the person who organises tourist expeditions'. Banks and Barry's work 'might have been done six months ago, instead of Mr Cook's circus … It really is a monstrous outrage.'[104] Grant continues:

… [Smirke] wrote to me, 'Shall you or I ever live

to see all this chaos ever come to an end? You will, I have no doubt, but that I shall see the end is very doubtful indeed.' I am equally despondent.[105]

In the event, work on Burlington House itself progressed quickly to start with. Smirke noted that 'the dryness of the summer of 1868 was very favourable'[106] and that 'over two hundred workmen had been at work on the project, with no accident occurring.'[107] Part of the building was sufficiently finished for the Royal Academy assembly to hold its first meeting there in November 1868, with the first summer exhibition, preceded by the annual dinner, in May 1869. However, Banks and Barry's new courtyard buildings were not ready until late in 1873, which meant that three of the 'Learned Societies' had to stay in Burlington House, which held up Smirke's work. The Gibson Gallery on the top floor of Burlington House was not to be opened until 1876.

The Academy was slow to remove itself entirely from Trafalgar Square. Only in 1871 was it decided that the 'officers and servants' of the Royal Academy who were actually living in the National Gallery building should be removed as soon as possible as they were a potential fire hazard to the collection. The library was not moved from the Trafalgar Square building until March 1874. Richard Redgrave's description of the Academy dinner on 31 December 1873 records Grant's elegiac remarks on his own long career:

I finished the old year at the Royal Academy, dining with the old and the incoming council, as our usual practise is. The dinner was so far unusual in that we this day took living possession of Burlington House, and dined in one of the suites of rooms … where … the noble proprietor and architect used to hold his pomp and state. After dinner, the President … told us a curious fact. 'In this very room', said he, 'forty two years ago, I commenced my professional practise as a London portrait painter … Little chance seemed there then that I should take my place as your President at the first dinner of the Academy council in the same chamber.'[108]

12

ROYAL ACADEMY MATTERS AND FRIENDSHIP WITH LANDSEER

Grant does not seem to have been particularly interested in the Royal Academy students and was criticised for never having taught in the Life School while he was an Academician, although he said that he frequently inspected the students' work. However, in his four surviving Royal Academy discourses his advice to the students was good. G.D. Leslie, in his *Inner Life of the Royal Academy*, writes of this: *Sir Francis Grant took a considerable amount of pains and trouble in the presentation of the Discourses which he delivered to the students on the occasions of the annual distribution of the prizes. I remember him bringing the manuscript of the first one he delivered, to Sir Edwin Landseer, for his advice and criticism … and how nervous Sir Francis seemed about it as he read it over to Sir Edwin, who suggested a few slight alterations. I heard most of Grant's discourses and I admired them greatly for their straight-forward soundness and common sense.*[109]

Grant advocated the importance of the study of old masters, and referred to the great asset that the constantly increasing national collection was to students, as well as, in the 1870s, the series of winter exhibitions at the Academy of collections of old master paintings and of British painters of the past. In addition, the study of paintings should be combined with the study of anatomy and working from nature. He saw the history of painting as a matter of progress (a thoroughly Victorian view), and did not really appreciate the merits of the early, so-called primitive masters. He says (in a different context): 'Durer and Van Eyck were the fathers of art, but much greater men followed.'[110] These certainly did not include the Pre-Raphaelites, whom he hated. Of this movement he remarked:
I think that pre-Raphaelitism has been most injurious to art. It has none of that largeness of ideas which exists in the works of such men as Sir Joshua Reynolds, Wilson and Turner … but it descends to a littleness which is below art.[111]
For Turner, however, he had huge reverence, referring to him as
immortal Turner, whose early works, and most of his middle and best period, must be ranked among the noblest examples of landscape painting that the world has ever produced … His later works … were wonderful in their

luminous qualities … I well remember when the light began to fail in our galleries, so luminous were they that they actually seemed to emit light.[112]

When discussing landscape painting, Grant, perhaps surprisingly, revealed his admiration for Constable. He stressed the importance of trying 'to reach that freshness of nature, of which we have so many fine examples by Constable'.[113] On the art of portraiture, he had to 'warn the student against the fatal error of mannerism and affectation'[114] and spoke on another occasion of 'the necessity of cultivating taste and refinement in Art'.[115] He had also stated a few years earlier, perhaps rather obviously, that two of the most vital ingredients of a painting were good drawing and harmonious colour – as well as the composition and the arrangement of masses of light and shadow. On this last point, he told the students, with evident approval, that he had 'recently heard Sir Edwin Landseer make the following observation … "A painter should endeavour to express his Art by substance, which in nature is never rendered by hard outline"'.[116]

Grant was also concerned about the dangers of showing too much concern with what the public thought and had hoisted a stark warning: 'Public opinion in Art is very often wrong.'[117] On the pernicious effects of art criticism, he issued a caution to the Academy's students in 1867: 'Do not be too much influenced by the Art Literature of the Press.'[118] Returning to the question of public opinion in his last surviving discourse, he fired a memorable parting shot:
What we require is that the public, who as a whole are profoundly ignorant of art, should be better educated. True it is that in the long run they judge rightly, but they require at least one hundred years to know good art from bad.[119]
The Academy's winter exhibitions of old masters and earlier British paintings, drawn from private collections throughout the country, have already been mentioned. These started in 1870 and were one of the most important innovations of Grant's presidency. It has been suggested that these exhibitions were the idea of Lord Leighton, who was to be Grant's successor as President. However, winter exhibitions (if not entirely of old

masters), were already a feature in Scotland, and that Grant was well aware of them and appreciated their value is made clear by a letter he had written to an unknown recipient at the Royal Scottish Academy in 1859: 'I am very glad to hear you have had a propitious exhibition this winter. I think the Royal Academy of Scotland may read a lesson to other brethren in this for we are far behind you in spirit and enterprise.'[120] It is therefore likely that they were instigated by Grant himself.

When Grant became President of the Royal Academy, he depended quite heavily for support on Landseer, who had stepped aside for him. This is evident from a series of letters between the two men (many more surviving from Landseer to Grant than vice versa) which started in the late 1840s and continued until Landseer's death in 1873. They illustrate how unfitted Landseer's mercurial and touchy temperament, combined with his bouts of illness and depression, would have been for the task of President. They also show, particularly in the early years of Grant's presidency, how much background help and support Landseer gave him. For example, Grant valued Landseer's opinion to such an extent that in September 1866 he sent the projected Royal Academy plans to Landseer in France for his comments. In 1869 Landseer also advised Grant on how he should deal with his jealousy of Winterhalter's success in royal circles. When Grant failed to put Winterhalter on a list of candidates for honorary member-ship of the Royal Academy, Landseer wrote to him pointing out that he was failing to recognise Winterhalter's worth and was being unfair. In addition, Winterhalter's exclusion would annoy Queen Victoria.

On a lighter note are those letters from Landseer to Grant about his progress round Scotland, where both artists spent a consider-able amount of time every autumn, although Grant spent less time there after he became President of the Academy:

I went to the Court of Balmoral, dined, danced and prattled … on my arrival at Lord Breadalbane's I found a large party. Ladies are ever acknowledged the chief ornament and comfort of life in a Deer Forest, I must say I prefer the deer to the darlings … I hope to

return to my easel with a goodly healthy appetite for work![121]

This, and some of the excerpts from Landseer's letters that follow, give a clear indication of how close the two men were and how their reliance was mutual. In 1858, for example, Landseer got himself into trouble for having done a drawing of Disraeli as 'Protection' and appealed to Grant for help. He wrote from Brighton:

I really thought the fun would be laughed at and not construed into a formidable thing … I don't mean to ask you to go to Dizzy, but if necessary to alter the drawing.[122]

Two days later he wrote again:

I have yielded to your protection instead of my own![123]

In a similar vein is a letter of May 1869:

One line to say I shall always remember with pleasure your friendly kindness in extricating me from my pictorial troubles.[124]

Another letter, of April 1870, asks Grant to explain a technical problem to the Prince of Wales:

Every thing conspires to check the success of my Boat picture … Let me trust to your explaining to the P. of Wales the difficulties I have had attempting to graft a new picture on an old one.[125]

Landseer was to die on 1 October 1873 and what is probably his last letter is one to Grant which is redolent of the mental depression that had afflicted him since the 1850s: 'I am so nearly dead. I wish to Heaven you could call here.'[126]

Having become such an active president, it is hardly surprising that Grant painted fewer pictures, although he continued to exhibit as many works as he had done before. Probably his most successful portrait at this period is that of Orlando, Earl of Bradford of 1866, the subject set with marked realism against a landscape which is convincingly related to the figure. Grant made an intriguing oil study for this portrait which has a plain background. In a curious way the elongated, mentally detached figure seems to look forward to the portraits of Whistler and Sargent much later in the century.

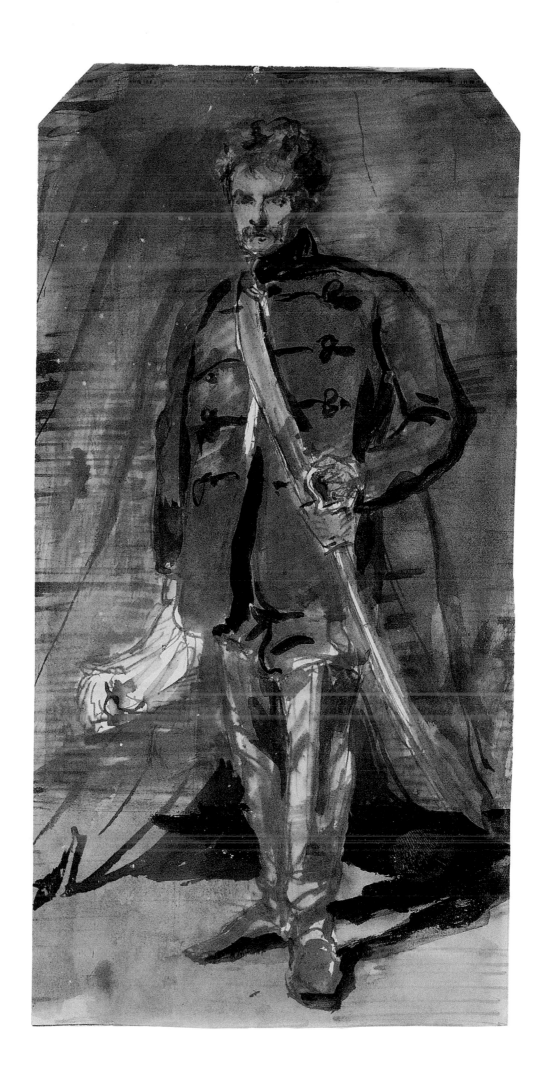

49. *Sir Colin Campbell,*
*Lord Clyde, c.*1860
National Portrait Gallery, London
(cat.no.60)

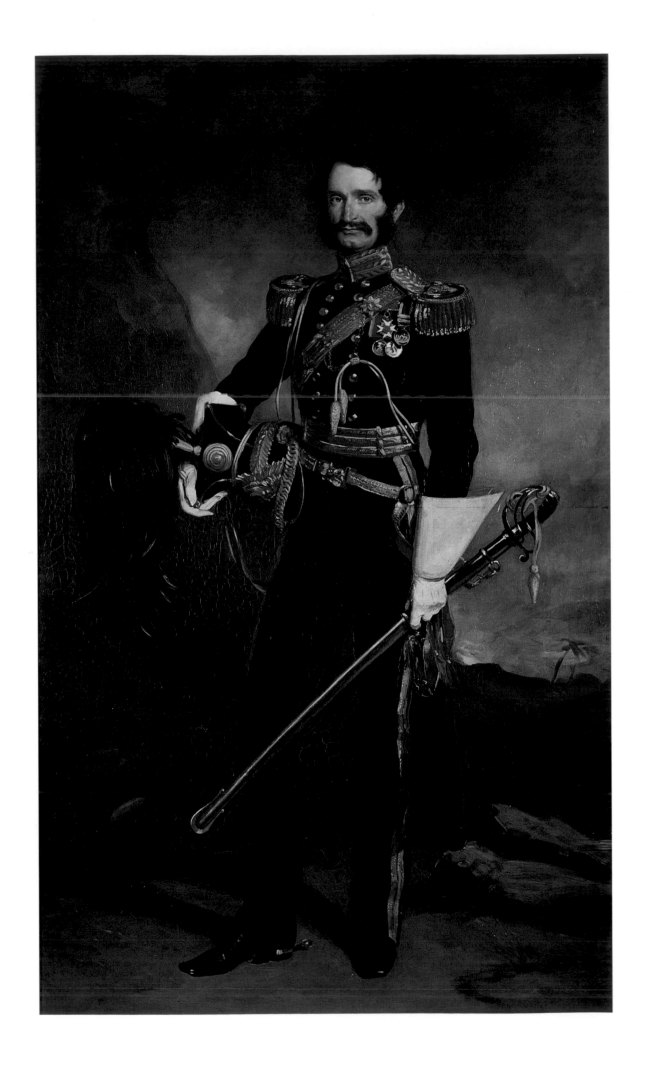

13

LATE WORK

Although Grant's production rate inevitably fell during the later years of his life, he continued to produce interesting work, which included a number of family portraits, a self-portrait, some more formal portraits including a number of works of military men [PLATE 49], and a series of paintings of deer, this last group a complete departure from his earlier work.

In the course of 1868 he painted two quite different portraits of his favourite brother Hope, described in the sitters' book as 'Two full lengths of General Sir Hope Grant, one before Pekin, the other playing his violincello'. Hope, a music lover as well as a soldier, spent much of his army career abroad and seems to have taken a number of his brother's paintings with him. Writing of his house in Cawnpore in 1845, he refers to '… its spacious rooms. These latter I decorated with paintings by my brother, and with my curiosities from China, and here too I established my piano and violincello.'[127]

Hope Grant and his brother attended a dinner at the Royal Academy in 1862 when their presence together was noted by Richard Redgrave: 'Lord Elgin and Sir Hope Grant just arrived from China were present, and both spoke. Many were the compliments to the brothers Grant – the distinguished painter and the illustrious general.'[128] Hope Grant also describes the dinner, clearly spoiled for the brave soldier by the terrors of having to make a speech:

I managed to make my Maiden Speech without much difficulty or breakdown. I only said a little but little was expected of me. I confess that after it was over I felt as if a horrible load had been taken off my mind – and it was more trying than having to fight a battle … I was sitting next to my brother and after dinner David Roberts the painter came up and said: 'You have made the most charming picture of "Peace and War". There is your brother, happy, contented looking and comfortable and you, tall, worn and gaunt – it has quite delighted us.'[129]

Grant had already painted a number of portraits of Hope. These included the full-length of 1853 with military accoutrements and battle honours set in a generalised Indian landscape [PLATE 50], a sketch made for their mother before Hope's departure for India in 1857 and a half-length in uniform painted in 1865 for Hope's wife which was sent out to Madras. A painting of Grant in his studio by John Ballantyne [PLATE 51] shows the half-length of Hope and an unfinished portrait of the Duchess of Sutherland.

There is a marked contrast between the two portraits that Grant now painted. The one set 'before Pekin' shows Hope Grant standing in front of a cannon in the Forbidden City near the Anting Gate, the setting quite carefully depicted. He has a faint smile on his face, wears a plain uniform and looks off to the viewer's left. It is painted with breadth and realism. The second portrait is far removed from war, depicting Hope as a sensitive musician playing his violincello.

In these years, Grant also made two portraits of his favourite daughter Elizabeth, of whom he was inordinately fond. She was the only one of his four daughters never to marry. When Elizabeth was away from home, as she often was, they corresponded mainly about family affairs but the correspondence does reveal a good deal about Grant's character as well as containing interesting references to Royal Academy matters and particular paintings. The earlier of the two portraits is called *Elizabeth with a White Dog* and is disguised as a bourgeois genre scene so that it could be presented to the Royal Academy as Grant's diploma work, in place of the portrait

50. *General Sir James Hope Grant*
Scottish National Portrait Gallery, Edinburgh
(cat.no.58)

JOHN BALLANTYNE 1815–1897
51. *Sir Francis Grant in his Studio*, 1866
National Portrait Gallery, London
(cat.no.12)

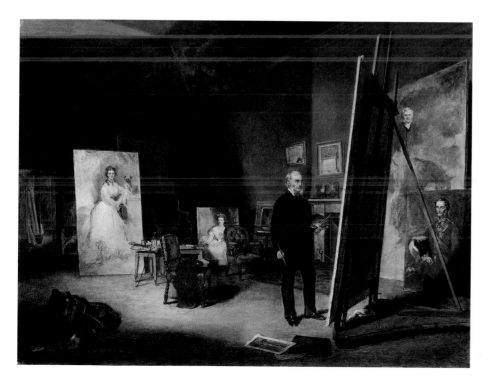

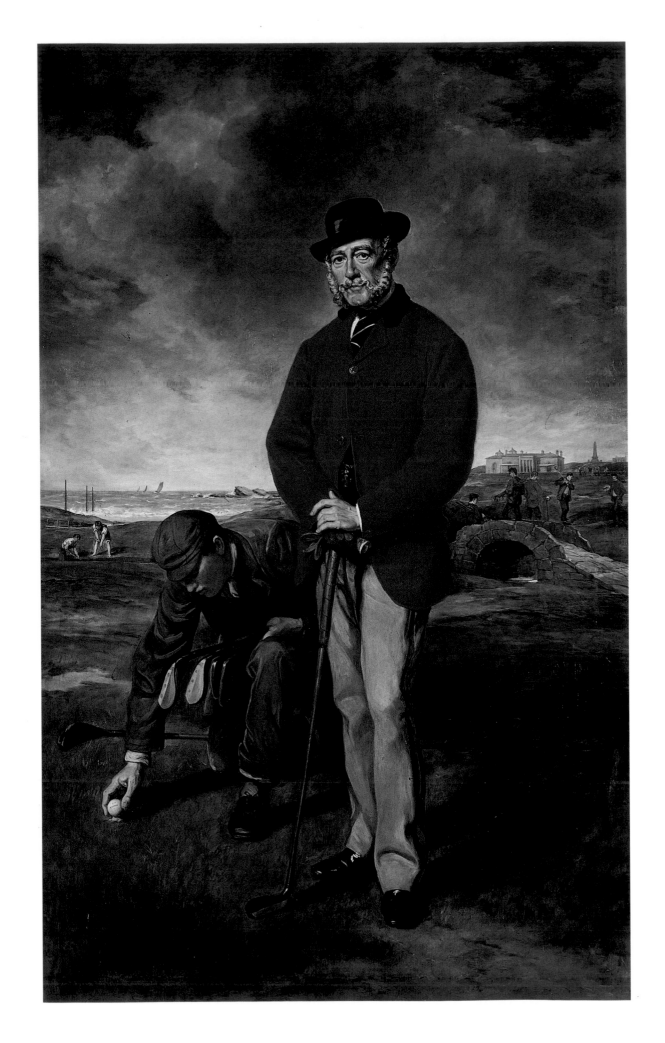

52. *John Whyte-Melville,* 1874
Reproduced by kind permission
of The Royal and Ancient Golf Club
of St Andrews

53. *Edward Nugent,*
6th Earl of Milltown, 1875
National Gallery of Ireland,
Dublin (cat.no.63)

of Elizabeth's sister Isabella which Grant had withdrawn. In 1874 Grant painted Elizabeth again, in a painting called *Knitting a Stocking* [PLATE 55], which is more definitely a genre picture. When it was exhibited at the Royal Academy in the same year, Grant wrote Elizabeth an amusing letter on how it had been hung, which illustrates his reservations about mixed exhibitions in general.

Apart from the self-portrait of about 1826 at Invercauld, showing Grant as a good looking young man and a sketch showing himself with a palette painting a mother and child, of about 1839, there are two other principal self-portraits: that of around 1843, now in the National Portrait Gallery [PLATE 54] and one of 1876 in the Royal Academy [PLATE 48]. The former portrait was presented to the nation by his daughter Elizabeth in 1901. Grant has set himself against a plain dark background, which has a smoky redness around the contours of his head and shoulders. It has a Lawrence-like glamour, but the technique is closer to Grant's Scottish contemporary, John Watson Gordon.

The later self-portrait was first proposed by the Royal Academy in 1868, when the Academicians decided that

the president should be requested to paint a portrait of himself in commemoration of his important services in obtaining the site, and carrying to a successful issue, the negotiations for the permanent establishment of the Royal Academy at Burlington House.[130]

Grant, however, did not fulfil this request until the summer of 1876, when he produced a bust-length portrait. When the Academy's Council asked Grant how much they were indebted to him for the portrait, he replied that his *impression was that the commission was to paint a full length which he had not been able to execute, but that he wished to present the head that he had sent, and did not feel justified in availing himself of the proposal of the council to pay for it.*[131]

Despite the further insistence of the Council that this was not what they had intended, Grant stood firm, and presented the bust-length portrait.

As in the self-portrait of 1843, Grant, now a distinguished looking seventy-three-year old, has set himself before a plain background. The portrait is handled with freedom and sponta-

neity. He wears a monocle, the Royal Academy President's medal and a cravat embellished with a fox's mask pin, a subtle reference to his other world of country pursuits.

Grant's two finest portraits from the last decade of his life are a large golfing portrait of *John Whyte-Melville* [PLATE 52] and an equally large portrait of the *6th Earl of Milltown* [PLATE 53], painted in 1874 and 1875 respectively. Whyte-Melville, in his brilliant red coat, poses rather self-consciously and a little stiffly before the course at St Andrews, while his caddy, much more naturally positioned, crouches to his right and carefully places a golf ball on a tee. The scene behind, which includes the famous little bridge over the Swilken burn, a number of golfers on the other side of the burn, and a view of the distant clubhouse, is painted with a quite painstaking realism which may owe something to the tonalities of contemporary photography.

Lord Milltown is much more convincingly posed, holding hat and gloves in one hand and clasping a gun to his body with the other. He stands in parkland with his seat, Russborough, accurately depicted against the low horizon. The characterisation of Milltown, the vigorous yet controlled handling of paint, and the way in which the subject and landscape are interrelated are in effect quite Rubensian in quality.

Grant was not particularly well during the last two or three years of his life but he went on accepting commissions, even being willing to work away from his studio if the sitter was deemed important enough. This is clear from a letter written by the Duke of Richmond as late as 1876:

I am delighted to find my tenantry have made so good a choice – my office is in the Privy Council Office in Whitehall … I shall be there from twelve o'clock to five on Friday and very glad to see you …[132]

In order to cope with his increasing infirmities and to enable him to go on painting, Grant installed in his studio what he described as a 'studio railway', a wheeled device on tracks that allowed him to move backwards and forwards in front of his easel in a seated position. There was a handrail on one side for grasping, and propulsion was by means of a free leg (backwards) or by free-wheeling on the slight incline of the track towards the easel. He

54. Self-portrait, *c.*1845
National Portrait Gallery, London
(cat.no.5)

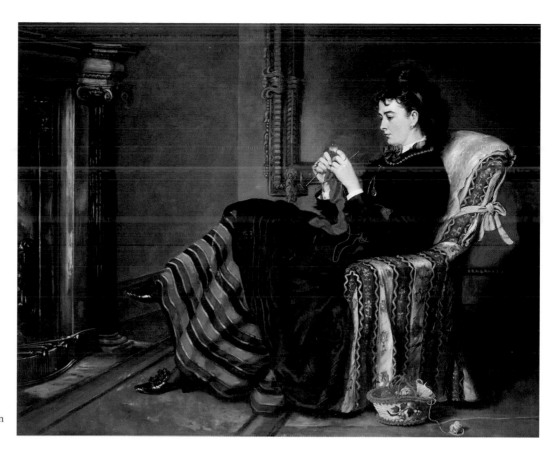

55. *Knitting a Stocking*, 1874
The Charles and Barbara Robertson Collection
(cat.no.15)

mentions this odd contraption in a letter of 1876 to the painter George Vicat Cole, who had recently broken his leg, and offers to lend it to him. Grant remarks: 'When I am crushed with many sitters I make use of it when I am tired.'[133]

It was in these final years that Grant turned to painting moorland scenes populated only by deer. The explanation for this extraordinary development so late in his life may be that, having felt the need of subject matter that would release him from his endless obligations to his sitters, but being inhibited by Landseer's virtuosity in this field, he did not make the attempt at the new subject until after his friend's death in 1873. Once started, Grant took his deer pictures intensely seriously. In November 1875 he wrote, rather touchingly, to his daughter Elizabeth from Sussex Place:
My stuffed stag has arrived. He is most valuable for colour only. Mama and I went to the Zoological Gardens and I sketched the old stag's head for an hour whilst Mama took a whole round of the gardens visiting the Hippopotamus family. We then walked home through the lovely bright sunshine.[134]
All of the deer pictures are set in the heathery Perthshire hills that Grant knew so well from

his earliest days. His approach to this kind of subject matter is, in fact, quite different from that of Landseer. There is no pain, no dying, no sentiment. They are simply based on acute observation. The stag in his *Dead Stag*, for example, lies dead in the heather, its head in a burn, exactly as it fell, the ordinary visual facts fully understood by someone who had shot deer all his life.

The most ambitious of these late paintings is *A Royal Procession* [PLATE 56] which shows eight 'royal' stags and two hinds on a bare, reddish brown hillside. About a third of the picture is a cloudy grey sky which emphasises the stillness of the landscape, where the stags raise their heads expectantly. That Grant saw these pictures as a serious development of his art is suggested by the fact that he exhibited several of them at the Royal Academy between 1876 and 1878.

In 1878, the final year of his life, he also exhibited once again in Paris, at the third *Exposition Universelle*, along with a number of other British artists. He sent out three paintings, *The Duke of Cambridge at the Battle of Alma*, which his brother Hope had commissioned in 1867, *Sir Richard Sutton and His Hounds* of 1846 and the full-length *Lord*

56. *A Royal Procession*, c.1877
Private Collection, Courtesy of Simon
C. Dickinson Ltd (cat.no.64)

Gough. British art, however, could no longer cause the stir that it had done in 1855 and the critics were generally unenthusiastic. One critic, however, did single Grant out for a complimentary mention: 'With M. Grant there is still something, a well-balanced sharpness of truth and observation.'[135] Grant was awarded one of the six *Rappels* of the *Médailles de Première Classe*.

Despite the pressures that were inevitably created by catering for conventional tastes over such a long period – he exhibited 259 paintings at the Royal Academy during his lifetime – there is little doubt that Grant loved the art of painting for its own sake. If nothing else, his late deer paintings prove this, as do the few small portraits which he painted in his last two years and gave away as presents. This love of his art is movingly expressed in a letter to his daughter written some time in the early

1870s: 'I have never been out of the house since my arrival here [Melton] … I am happier in my painting room than out of doors …'.[136] His growing weariness can be sensed in a letter written in the winter of 1877: 'I am much as usual, very feeble at times.'[137]

Francis Grant died on 5 October 1878 in Melton Mowbray. The Royal Academy wished to arrange his interment in St Paul's Cathedral but this offer was declined in favour of his beloved Melton. The Royal Academicians travelled by train from St Pancras to Melton where most of the town's shops closed for the afternoon. There was a huge turnout for the funeral. Among the pall-bearers were the Duke of Rutland, Viscount Hardinge and four fellow Academicians – William Calder Marshall, Charles Cope, William Frith and Richard Redgrave, the last two Grant's particular friends.

NOTES

1. J.P. Neale, *Views of the Seats of Noblemen and Gentlemen*, second series, vol.IV, London 1828, no pagination.

2. Henry Knollys (ed.), *Life of Sir James Hope Grant, with Selections from his Correspondence*, Edinburgh 1894, vol.I, p.1.

3. J.Y. Tait (ed.), *Journal of Sir Walter Scott 1825–32*, Edinburgh 1939–46, vol.III, pp.155–6.

4. Knollys, as cited above, vol.I, p.1.

5. Obituary in the *Telegraph*, 4 June 1878. A copy of this painting, by Grant, was sold after Grant's death at his studio sale, Christie's, 28 March 1879, lot 69, for £46.4s.

6. *Illustrated London News*, 10 March 1866, p.232.

7. Letters to Blackwoods from Francis Grant, 1827, Blackwood Papers, MSS 4019, ff.141–2, National Library of Scotland, Edinburgh.

8. *Blackwood's Magazine*, Edinburgh 1817.

9. William Bell Scott, *Autobiography*, London 1892, vol.I, p.84.

10. Allan Cunningham, *Life of Sir David Wilkie*, London 1843, vol.II, p.107.

11. Undated letter from Kilgraston, MSS 9994, f.180, National Library of Scotland, Edinburgh.

12. Unpublished manuscript of the Earl of Wemyss' memories, p.189, Private Collection.

13. *Catalogue of the Pictures, Ancient and Modern, in Kinfauns Castle*, Kinfauns Press, Perthshire, 1833.

14. Presidential Discourse 1873, Royal Academy, London.

15. Presidential Discourse 1873, Royal Academy, London.

16. Presidential Discourse 1873, Royal Academy, London.

17. Fragment of a manuscript dated 11 January 1860, annotated by Grant, MSS. ADD 28501, f.131, The British Museum, London.

18. Edmond About, 'Voyage à travers l'Exposition des Beaux Arts', Paris 1855, pp.1–35.

19. Review in *The Academy*, 12 October 1878.

20. Presidential Discourse 1873, Royal Academy, London.

21. Presidential Discourse 1873, Royal Academy, London.

22. Letter from Eleanor Stanley to her mother from Balmoral, 19 September 1854, quoted in S. Erskine (ed.), *Twenty Years at Court: From the Correspondence of the Hon. Eleanor Stanley*, London 1916, p.263.

23. C.J. Apperley, *Nimrod's Hunting Tours*, London 1835, pp.139–40.

24. As cited above.

25. C.J. Apperley's commentary on the engraving of Grant's *The Ascot Hunt*, published by Hodgson & Graves, London 1838.

26. J.Y. Tait (ed.), *Journal of Sir Walter Scott 1825–32*, Edinburgh 1939–46, vol.III, pp.155–6.

27. Copy of 1898 by Elizabeth Grant of a list of paintings painted by Francis Grant, made by her mother, Lady Grant, National Portrait Gallery, London.

28. James Skene, *Memoirs of Sir Walter Scott*, London 1909, p.191.

29. H.J.C. Grierson (ed.), *Letters of Sir Walter Scott*, London 1932, vol.XI, p.495.

30. Francis Grant's obituary in the *Annual Report of the Royal Scottish Academy* 1878, Scottish National Portrait Gallery, Edinburgh.

31. C.J. Apperley's commentary on the engraving of Grant's *The Ascot Hunt*, published by Hodgson & Graves, London 1838.

32. Edmond About, 'Voyage à travers l'Exposition des Beaux Arts', Paris 1855, pp.1–35.

33. As cited above.

34. Queen Victoria's Diary, 24 November 1838, in 'Extracts from the Diary of Queen Victoria relating to Sir Francis Grant, copied by Sir Owen Morshead from Princess Beatrice's transcript of the Queen's Diary from February 1838 – November 1845', Steegman Papers, National Portrait Gallery, London.

35. Letter from Francis Grant to Marquis of Granby, postmarked 29 November 1838, Private Collection.

36. Queen Victoria's Diary, as cited above, 4 May 1838.

37. Queen Victoria's Diary, as cited above, 24 November 1838. This was 12 Park Village West, Regent's Park, where Grant lived from 1835 to 1841.

38. Queen Victoria's Diary, as cited above, 24 November 1838.

39. Queen Victoria's Diary, as cited above, 27 November 1838.

40. Queen Victoria's Diary, as cited above, 29 December 1838.

41. Queen Victoria's Diary, as cited above, 31 July 1839.

42. Grant's London studio from 1835 to 1841 was at 12 Park Village West, Regent's Park, London.

43. H. Wyndham (ed.), *Correspondence of Sarah Spencer, Lady Lyttleton*, London 1912, p.332.

44. S. Erskine (ed.), *Twenty Years at Court: From the Correspondence of the Hon. Eleanor Stanley*, London 1916, pp.107–8.

45. Queen Victoria's Diary, as cited above, 25 October 1845.

46. S. Erskine (ed.), *Twenty Years at Court: From the Correspondence of the Hon. Eleanor Stanley*, London 1916, pp.97–8.

47. Queen Victoria's Diary, as cited above, 1845.

48. Minto Papers, MSS 11884, f.53, National Library of Scotland, Edinburgh.

49. Minto Papers, MSS 11884, f.58, National Library of Scotland, Edinburgh.

50. Minto Papers, MSS 11884, f.63, National Library of Scotland, Edinburgh.

51. Minto Papers, MSS 11885, f.52, National Library of Scotland, Edinburgh.

52. Minto Papers, MSS 11885, f.52. Lord Minto wears the Grand Cross of the Bath. National Library of Scotland, Edinburgh.

53. Minto Papers, MSS 11885, f.53, National Library of Scotland, Edinburgh.

54. Minto Papers, MSS 11885–6, f.63, National Library of Scotland, Edinburgh.

55. Minto Papers, MSS 11886, f.29, National Library of Scotland, Edinburgh.

56. *The Diary of Benjamin Robert Haydon*, London 1808–46, vol.V, pp.181–2.

57. As cited above.

58. Extract from *The Post* in *A Guide to the Exhibition at the Royal Academy*, 1844, Royal Academy, London.

59. Letter from Francis Grant to the Duke of Rutland, Private Collection.

60. 'Copy of list of pictures, by my father, Sir Francis Grant, from a manuscript book kept by my mother, Lady Grant, December 1898', National Portrait Gallery, London.

61. Lady Grant was said to have burnt the original sitters' book.

62. Quoted in *A Catalogue of Paintings at Thorpe Hall, Yorkshire*, by Lady Macdonald of the Isles, 1892.

63. See Sitters' Book entries, such as: '1845 (June) 2 small copies of Marquis & Marchioness of Bristol, £63 each'; '1846 (April) Copy of late Lord Wharncliffe presented to his family by the W.G.C. Yeomanry £315'; '1848 (Aug) small copy of Lady Katherine Jermyn, that was painted in 1839 for the Duke of Rutland £52.10s', National Portrait Gallery, London.

64. C. Grosvenor and S. Wortley, *The First Lady Wharncliffe and Her Family*, London 1927, vol.2, pp.328–8.

65. R. Nevill (ed.), *Leaves from the Note-Books of Lady Dorothy Nevill*, London 1907, p188.

66. Longley Papers, vol.2, ff.83–4, Lambeth Palace Library, London.

67. Longley Papers, vol.2, ff.87–8, Lambeth Palace Library, London.

68. Longley Papers, vol.2, ff.89–90, Lambeth Palace Library, London.

69. Longley Papers, vol.2, ff.92–5, Lambeth Palace Library, London.

70. An entry from Henry Keppel's diary, dated 20 October 1847, quoted in R. Ormond, *Early Victorian Portraits*, London 1973, pp.63–4.

71. Undated letter addressed to 'Frank Grant RA', formerly in a Grant family collection of approximately sixty-five letters from Landseer to Grant, kept by Grant's widow, Lady Grant. They were sold to the USA, probably in the 1940s, and then sold again at Christie's, London on 29 May 1986, lot 312, when they were bought by the Victoria & Albert Museum, London. The letters are contained in a book, inscribed 'Ex Libris Col F. Grant', and appear mainly to have been arranged chronologically, although some are not dated. In 1987 they were not numbered.

72. *The Times*, 29 April 1854.

73. *The Times*, 1 May 1854.

74. Lord Russell's comment on his and Disraeli's portraits, *The Times*, 1 May 1854.

75. Entry dated 8 June 1853 from Macaulay's Journal, vol.VI, December 1852 – January 1854, Trinity College, Cambridge.

76. Macaulay's Journal, 19 May 1853.

77. Macaulay's Journal, 13 June 1853.

78. Macaulay's Journal, 22 June 1853.

79. Letter from Francis Grant to George Scharf, Director of the National Portrait Gallery, 1877, National Portrait Gallery, London.

80. Letter from John Evelyn Denison to Col. S.W. Welfitt of Langwith, Private Collection.

81. Entry from the journal of Lady Lucy Grant (vol.30), dated Tuesday 15 May 1855, recording travels in Germany, Switzerland and France, Scottish Record Office, Edinburgh.

82. As cited above, 2 June 1855.

83. *Journal d'Eugène Delacroix*, Paris 1932, vol.II, pp.338–9.

84. *Le Moniteur Universel*, 2 June 1855.

85. C.P. Baudelaire, 'Curiosités Esthétiques', *Salon de 1859* (1956 edition), p.309.

86. *Fraser's Magazine*, June 1860, pp.878–9.

87. Letter from Francis Grant in the Steegman Papers, National Portrait Gallery, London.

88. Letter from Francis Grant in autograph folder no.240 (miscellaneous artists' letters), New College, Edinburgh.

89. R. and S. Redgrave, *A Century of Painters of the English School*, London 1890, p.328.

90. *Illustrated London News*, 10 March 1866, p.232.

91. Letter from Queen Victoria to Lord Russell, 19 February 1866, ref. C15/30, Royal Collection, Windsor. There is a copy of this letter in the Steegman Papers, National Portrait Gallery, London.

92. *Richard Redgrave, A Memoir*, compiled from his diary by F.M. Redgrave, London 1891, p.285.

93. Minutes of the General Assembly of the Royal Academy, 27 March 1850, vol.V, p.160, Royal Academy, London.

94. Broadlands Manuscripts, WFC/G/22, Private Collection.

95. As cited above.

96. Correspondence from Francis Grant relating to the new site for the Royal Academy 1866, pp.6–7, Royal Academy, London.

97. Letter from Landseer to Grant, 2 September 1866, written from France, Victoria & Albert Museum, London.

98. Letter of 6 January 1867 included in letters presented to the Royal Academy in July 1962, by Sir Albert Richardson, MIS/GRI–20. The letters are not numbered individually; several are undated but seem to commence in late 1866. They include nineteen letters from Grant to Messrs Banks & Barry (Robert Banks and Charles Barry, son of Sir Charles Barry), Royal Academy, London.

99. As cited above, letter of 11 March 1867, written from The Lodge, Melton Mowbray.

100. As cited above, letter of 31 March 1867, written from 27 Sussex Place, London.

101. As cited above, undated letter, probably of late April 1867.

102. As cited above, letter of 1 May 1867, written from 27 Sussex Place, London.

103. As cited above, undated letter, probably of May 1867, written on 27 Sussex Place writing paper.

104. Letter to Sir Douglas Galton, Head of the Office of Works, probably 2 December 1869, written from 27 Sussex Place, London, ADD MSS 59847, f.89, The British Museum, London.

105. As cited above.

106. *Annual Report of the Royal Academy*, 1868, p.45, Royal Academy, London.

107. As cited above.

108. *Richard Redgrave, A Memoir*, compiled from his diary by F.M. Redgrave, London 1891, p.330.

109. G.D. Leslie, *The Inner Life of the Royal Academy*, London 1914, p.94.

110. *Report of the Royal Academy Commissioners*, 1863, paragraph 2495, Royal Academy, London.

111. *Report of the Royal Academy Commissioners*, 1863, paragraph 2468, Royal Academy, London.

112. Presidential Discourse 1875, Royal Academy, London.

113. Presidential Discourse 1873, Royal Academy, London.

114. Presidential Discourse of 10 December 1868, Royal Academy, London.

115. Presidential Discourse 1873, Royal Academy, London.

116. Presidential Discourse of 10 December 1867. Printed version in Royal Academy, London.

117. *Report of the Royal Academy Commissioners*, 1863, paragraph 2480, Royal Academy, London.

118. Presidential Discourse of 10 December 1867, Royal Academy, London.

119. Presidential Discourse 1875, Royal Academy, London.

120. *Annual Reports of the Royal Scottish Academy*, 1856–67, p.45A, Royal Scottish Academy, Edinburgh.

121. Letter from Landseer to Francis Grant dated 17 October 1859; see note 71.

122. As cited above, letter of 12 April 1858.

123. As cited above, letter of 14 April 1858.

124. As cited above, letter of 2 May 1869, written from St John's Wood Road, London.

125. As cited above, letter of 27 April 1870, written from St John's Wood Road, London to Grant at Sussex Place, London.

126. As cited above, date illegible, possibly 1 October, the date that Landseer died.

127. H. Knollys (ed.), *Life of Sir James Hope Grant, with Selections from his Correspondence*, Edinburgh 1894, vol.I, p.54.

128. *Richard Redgrave, A Memoir*, compiled from his diary by F.M. Redgrave, London 1891, p.257.

129. H. Knollys (ed.), *Life of Sir James Hope Grant, with Selections from his Correspondence*, Edinburgh, 1894, vol.II, p.206.

130. *Annual Report of the Royal Academy*, 1868, p.16, Royal Academy, London.

131. Council Minutes of the Royal Academy, 1876, vol.XV, pp.71–2, Royal Academy, London.

132. Letter from the Duke of Richmond to Francis Grant, 8 February 1876, written from 48 Belgrave Square, Private Collection.

133. Letter from Francis Grant to George Vicat Cole, spring 1876, Private Collection.

134. Letter from Francis Grant to Elizabeth Grant, 12 November 1875, written from 27 Sussex Place, Private Collection.

135. E. Duranty, 'Exposition Universelle de 1878 – Les Beaux Arts et les Arts Decoratifs', vol.I, *L'Art Moderne*, pp.149–71.

136. Letter from Francis Grant to Elizabeth Grant, 19 January 1877, written from The Lodge, Melton Mowbray, Private Collection.

137. Undated letter from Francis Grant to Elizabeth Grant, written from 27 Sussex Place, Private Collection.

CATALOGUE

All catalogue entries by Dr Catherine Wills;
all works by Sir Francis Grant unless otherwise
stated

Dimensions are given in centimetres, height
preceeding width

RA Royal Academy of Arts, London

RSA Royal Scottish Academy, Edinburgh

V&A Victoria and Albert Museum, London

VE Victorian Exhibition, New Gallery, London

NOTE
The publisher gratefully acknowledges the co-
operation of theTrustees of the National Library of
Scotland, Edinburgh; the Trustees of Lambeth
Palace Library, London; the National Portrait
Gallery, London; the Royal Academy, London; the
British Museum, London; the Victoria & Albert
Museum, London and the many private owners
who have given permission to quote from material
in their collections. Some collections have not
been catalogued and it has not been possible to
give reference numbers.

ROBERT GIBB 1801–1837
1 Kilgraston House, Perthshire, 1827

Plate 1
Oil on canvas, 42.4 × 62cm
Property of Charles G. Spence

Kilgraston House, near Bridge of Earn, Perthshire,
was rebuilt by Francis Grant's uncle, John Grant,
and inherited by his father, Francis, in 1793. Grant
spent his childhood summers there and treated it
as his home long after his eldest brother inherited
it in 1818.

Robert Gibb was born in Dundee and was
active in Edinburgh, where in 1826 he was one of
the founding members of the Scottish Academy.
Grant wrote of him in the Kinfauns catalogue
(see cat.no.70) in 1827:
*This young artist was bred to the profession of
house painting, but his zeal to excel as an artist
induced him to leave this occupation and com-
mence his career in Edinburgh as a landscape
painter without money, patronage or knowledge …
In this situation he was recommended to Lord Gray
… [who] has since employed him to paint several
pictures … Mr Gibb promises to arrive at consider-
able eminence as a faithful representer of nature.*
Grant occasionally used Gibb to paint landscape
backgrounds in his hunt pictures.

JOHN FERNELEY 1782–1860
2 John, Henry and Francis Grant at Melton Mowbray, 1823

Plate 3
Oil on canvas, 132.1 × 188cm
Signed and dated: J. Ferneley, Melton Mowbray,
1823
Leicestershire County Council Heritage Services

Francis Grant (centre) is mentioned as going to
hunt at Melton around 1820. Here he is seen with
his brother Henry (standing) who died in 1824, and
his oldest brother John (on the right). Leicester-
shire-based John Ferneley, a pupil of Ben Marshall,
was the leading sporting painter of his day and a
good friend of Grant, for whom he painted several
pictures and with whom he also collaborated,
Ferneley painting the horses and Grant the por-
traits.

3 Amelia Farquharson of Invercauld, c.1826

Oil on panel, 10.2 × 10.2cm
Private Collection

Francis Grant married Amelia Farquharson of
Invercauld at Kilgraston in Perthshire on 19 April
1826. She died after giving birth to their son, John
Emilius Grant, on 6 November 1827.

This tiny portrait shows how amateurish
Grant's works were at this stage of his life.

ALFRED GUILLAUME GABRIEL, COUNT
D'ORSAY 1800–1852
4 Francis Grant, 1845

Pencil on paper, 28.2 × 20.3cm
Signed and dated: A d'Orsay fecit. 16.Jany 1845
Private Collection

Count D'Orsay, sculptor and painter, was in his
youth a page to the Emperor Napoleon, after
which he joined the French Army. He came to
England with the widowed Countess of
Blessington in 1831, where for twenty years they
ran a notable salon. D'Orsay, graceful, handsome
and charming, was described in Benjamin
Haydon's *Journal* in 1838 as 'a complete Adonis'.
He was a famous dandy and arbiter of taste.
Eventually he ran out of money and returned to
Paris, dying in Dieppe of a spinal infection. Grant
was said to have been an intimate friend. D'Orsay
also made a bust of Grant and a plaster statuette.

This drawing is one of a series of 130 portraits
engraved and published in the late 1840s. Grant
painted an equestrian portrait of D'Orsay in 1836,
exhibited at the Royal Academy in that year, and
also painted him in 1848. D'Orsay also appears in
The Ascot Hunt of 1835. He was a member of the
Royal Hunt, although he probably first met Grant
at Melton.

5 Self-portrait, c.1845

Plate 54
Oil on canvas, 75.9 × 63.1cm
National Portrait Gallery, London
Not entered in Grant's sitters' book

This painting was presented by Grant's daughter,
Elizabeth, to the National Portrait Gallery in 1901.
She wrote to Lionel Cust, the Director, in Decem-
ber of that year:
*My brother, Col. Grant, used often to talk about
that picture of my father by himself going to the
National Portrait Gallery, but made no mention of
it in his will. It is now in my possession and I shall
be glad to give it to the Gallery.*

6 Self-portrait, 1876

Plate 48
Oil on canvas, 96 × 83.3cm
Royal Academy of Arts, London
Not entered in Grant's sitters' book

Grant was commissioned by the Royal Academy to
paint a full-length portrait of himself in 1868.
Grant did not fulfil his commission until the
summer of 1876, and then the portrait was only
bust-length. Grant insisted on presenting it and
returned the cheque sent in payment. As well as
wearing a fox's mask cravat pin, Grant wears the
Presidential medal around his neck on a chain,
arranged half under his coat lapel, and half in front
of it, as was normal practice.

MARY GRANT 1831–1908
7 Sir Francis Grant PRA, c.1865

Marble bust, 66.7cm
Royal Academy of Arts, London
Exhibited: RA 1866, no.878

Mary Grant was Francis Grant's niece, the eldest daughter of John Grant and his second wife, Lady Lucy Bruce. Born at Kilgraston, she studied sculpture in Florence, Rome and Paris, and worked in Scotland, before setting up a studio in London in 1868, where she was extremely successful. As well as portrait busts she produced high relief medallions and a few religious works, which included a crucifixion for St Mary's Cathedral, Edinburgh.

MARY GRANT
8 John Grant of Kilgraston, c.1870

Marble bust, 73cm
Property of Charles G. Spence
Exhibited: RA 1873, no.1440

Mary Grant's portrait bust of her father, John Grant (1798–1873), who was head of the family and who kept open house at Kilgraston for all his siblings until they were fully grown up, shows that like Francis, John was a remarkably good-looking man. A keen sportsman, he and Francis remained close friends throughout their lives. John Grant appears in *A Meet of the Fife Hounds* (cat.no.17).

MARY GRANT
9 General Sir James Hope Grant, 1870

Marble bust, 74cm
Property of Charles G. Spence
Exhibited: RA 1870, no.1057

Hope (1808–1875) was Francis's youngest and favourite brother who became a distinguished general. Educated at Edinburgh High School and in Switzerland, he became a cornet in the 9th Lancers in 1826. He remained in the Lancers until 1858 when he became a Major General. He spent a large part of his life abroad, in India and in China.

Francis Grant depicted his brother throughout his life, starting with a pencil drawing of Hope, aged twelve, in 1820.

'APE' (CARLO PELLEGRINI) 1839–1889
10 Sir Francis Grant, 1871

Chromo-lithograph, 35.5 × 23cm
Private Collection
From *Vanity Fair*, 29 April 1871
'Men of the Day, no.21'

Carlo Pellegrini, caricaturist and lithographer, was born in Capua in Italy. As a youth he joined Garibaldi and fought with his volunteer army. He came to England in the mid-1860s and made his name with a caricature of Disraeli. He worked for *Vanity Fair* under the pseudonym of 'Ape'.

In the commentary to this caricature, Grant is described thus:

As an artist he is remarkable for a great sympathy with the times in which and the people among whom he lives … He thus lays himself open to a more searching criticism, but his work seldom fails to endure it with success, and it is of a kind that will be more valuable to posterity as a true record of the present day than all the fanciful and misnamed 'historical' pictures that were ever painted … He delights in those two best products of England, beautiful women and beautiful horses. Sir Francis is not only an able artist, but an excellent President of that Royal Academy which represents the artistic aristocracy … there is no man who has fewer enemies, or whose qualities are more ungrudgingly recognised by all.

CHARLES BELL BIRCH ARA 1832–1893
11 Sir Edwin Landseer and Sir Francis Grant, c.1868

Pencil on paper, 18.5 × 14.9cm
National Portrait Gallery, London
Inscribed: Sir F. Grant PRA & Sir E. Landseer RA [and] sketched from life by C.B. Birch ARA
National Portrait Gallery, London

Birch was best known as a sculptor, but was also a watercolourist and illustrator. He studied at the Royal Academy schools and subsequently went to Berlin with his family, returning to England in 1832. Here he shows Grant, dressed as a country squire, listening to Landseer, dressed as a London gentleman, presumably at the Royal Academy.

JOHN BALLANTYNE RSA 1815–1897
12 Sir Francis Grant in his Studio, 1866

Plate 51
Oil on canvas, 71.1 × 92.1cm
National Portrait Gallery, London
Signed and dated 1866

Ballantyne was born in Kelso and studied in Edinburgh under William Allan, as well as in London, Paris and Rome. He is best known for a series of paintings of artists in their studios, which included Daniel Maclise, Edwin Landseer, Clarkson Stanfield, William Frith, William Holman Hunt and David Roberts.

Grant is shown painting a vast canvas, probably the equestrian portrait entered in his sitters' book in 1865 of 'G.F. Holroyed [*sic*] Esq'. The other portraits are also entered in the sitters' book for 1865: the Duchess of Sutherland, with her dogs, the half-length of the Countess of Wilton, a half-length of Hope Grant and the equestrian portrait of G. Wingfield Digby.

13 Mary Isabella Grant, c.1854

Plate 42
Oil on canvas, 127 × 102cm
Private Collection

Mary Isabella Grant (1832–1854) was Grant's eldest daughter. In 1852 she married Sir Francis Geary, 4th Bt of Oxon Heath, Kent.

This portrait is one of three known versions, all of equal quality. The original (Leicester Museum and Art Gallery) is recorded in the sitters' book in January 1850 and was exhibited that year at the Royal Academy. It was subsequently presented to the Royal Academy as Grant's diploma work but was withdrawn, presumably after Mary Isabella's premature death in childbirth. It was at this point, most probably, that the replicas were made by Grant for his family.

14 Mrs Markham, 1857

Plate 45 and cover
Oil on canvas, 223.5 × 132.3cm
Private Collection
Sitters' book: 1857 Feb. Miss Grant (Mrs Markham)
Full-length in walking dress
Exhibited: RA 1857, no.126; Society of Artists 1859; RSA 1859, no.221; Exposition Universelle 1867

Anne Emily Sophia Grant (1836–1880), Francis Grant's second daughter, always known as 'Daisy', married Col. William Markham, of Becca Hall, Yorkshire, in April 1857. William and Daisy Markham had six sons and seven daughters. This painting was acknowledged to be one of Grant's best female portraits.

15 Knitting a Stocking, 1874

Plate 55
Oil on canvas, 102 × 127cm
The Charles and Barbara Robertson Collection
Sitters' book: 1878 [Jan] Miss Grant Knitting a Stocking, painted in 1874
Exhibited: RA 1874, no.189

Elizabeth (c.1845–after 1901), Grant's youngest and favourite daughter, never married and father and daughter maintained a lively correspondence. Just before the 1874 exhibition opened, Grant wrote to Elizabeth with an entertaining description of her painting's position in the hang:
I must write once more to you – the passing of the pictures is over and now I am beginning to prepare for my great dinner … Miss Grant – that is you – is hung in the large room – your picture is greatly damaged because you are next to a great yellow sky by Abraham Cooper – the Committee quite acknowledged it and I proposed to put your picture at the other side of the same wall between two quiet pictures which would have suited it charmingly – and so I went home happy – when a cab arrived and a special messenger with a rider from the Committee

to say that when they proposed that arrangement, they forgot Miss Grant would be placed turning her back on the Duchess of Edinburgh, who is to occupy the centre, which would never do. They offered to do everything that was kind and put the picture in some good place in another room – but they thought I could not do better than leave it where it is – on the other side of the likeness, quite forgetting that it was quite as great a breach of etiquette for Miss Grant to be lolling in an arm chair and knitting a stocking in the presence of Her Royal Highness as turning her back – indeed, much worse – because in the last case Miss Grant might not be aware of the presence of the Royal Highness, whereas in the former there is no apology. Still I am charmed with their loyalty.

16 James Farquharson of Invercauld, 1844

Plate 2

Oil on canvas, 226 × 148.8cm
Trustees of the Captain Farquharson's Invercauld Trust
Sitters' book: 1844 [June] James Farquharson Esq. Of Invercauld in full Highland Dress. Full Length. £315

James Farquharson (1808–1862) was the brother of Grant's first wife, Amelia. James Farquharson's own wife and son were painted in 1845 by Grant to make a pendant to his portrait.

Farquharson's portrait is inspired by Raeburn's great Highland portraits. He inherited Invercauld from his mother, Catherine Farquharson, whose name he took. His father was a Ross. He wears both tartans, a Ross plaid and a Farquharson kilt.

17 A Meet of the Fife Hounds, 1833

Plate 7

Oil on canvas, 91.5 × 122cm
On loan from the Kintore Trust, Scottish National Portrait Gallery, Edinburgh
Sitters' book: Nov 1833 Hunt picture for the Earl of Kintore, containing several portraits of gentlemen, horses and hounds. £157.10s.

The engraved key identifies the figures as the following: 'Will – the second whip, Captain Wemyss of Wemyss Castle with his well known horse Diver, John Walker, huntsman, on his famous chestnut horse; Thom, first whip, on old Paddy, John Whyte Melville Esq of Mount Melville on grey mare by Palafax, John Dalyell Esq of Lingo with chestnut horse Willie Wafsal, John Grant Esq of Kilgraston on his brown Irish horse, the Lomond Hills, distant view of Rossie covert, Milnathort covert in the extreme distance. The Mount covert, and Lord Hopetoun's monument.'

The hounds are: Driver, Bertram, Brilliant, Coaxer, Tempest, Bluebell, Charter, Chronicle, Curious, Toper, Melody, Blucher, Milliner, Saladin, Bravery, Reveller, Ranter, Minister, Ajax, Champion, Daphne, Marplot, Sprightly and Limner.

18 A Meet of the Buccleuch Hounds, 1833

Plate 6

Oil on canvas, 91 × 122cm
Private Collection
Sitters' book: 1833 [Nov] Another hunt picture for the Earl of Kintore, containing portraits of gentlemen, horses and hounds. £157 10s.

The engraved key names the following riders: 'The Lord John Scott on Jamie by Caleb, Sir David Baird Bt. of Newbyth on his celebrated silver-tailed horse by Little Thomas [seen rear view], Mr Forbes' chestnut horse – "The Doctor" & groom. H. Forbes Esq of Callendar on Toby. Jack Skinner 2nd whip. Sir John Hope Bt of Pinkie, with his bay horse by Little Thomas. William Hay Esq of Dunse Castle on his brown mare by Antagonise. Will Williamson, huntsman on grey horse Richmond. His Grace the Duke of Buccleuch on bay horse Scarborough. The Lord Elcho on grey horse by Cannonball. John Cambell Esq of Glensaddle on his celebrated brown horse Elcho Castle. Hough, 1st whip. Duke's Kennels at St Boswells – St Boswells Green Inn, Eildon Hills.' The hounds were named as: Fencer, Brandy, Mentor, Marquis, Countess, Charmer, Harlequin, Jewels, Reveller, Hotspur, Sorcerer, Challenger, Solon, Susan, Lightsome.

19 Sketch for Hill Run with the Duke of Buccleuch's Hounds (The Skurry), c.1833

Oil on canvas, 40 × 86cm
Collection of the Duke of Buccleuch and Queensberry KT

Leading the field is Sir David Baird on 'Silvertail' who also appears in *A Meet of the Buccleuch Hounds* (cat.no.18).

A label on the back of the picture states 'Skurry, Sir Francis Grant. No.1 Mr Campbell of Saddel (right hand looking at the painting) no.2 Nat Marshall stud groom on Don Juan, no.3 Williamson on Grimble, no.4 Mr Hay of Dunse Castle, no.5 The Duke of Buccleuch on Jimmy, no.6 Lord Elcho on Carnwath, no.7 Sir David Baird on Silvertail, no.8 Lord Polwarth in distance'.

As with the two Kintore hunt pictures, the landscape is undoubtedly not by Grant and is almost certainly by the Revd John Thomson of Duddingston.

20 The Hunt Breakfast

Plate 8

Oil on canvas, 73.5 × 93cm
Collection of the Earl and Countess of Wemyss
Not entered in Grant's sitters' book

Lord Elcho of Gosford, the eldest son of Lord Wemyss, was part of Grant's sporting set; he appears in several of the hunt pictures and commissioned a painting of a hunt meet from Grant in 1834. Although it is not recorded, this hunt breakfast was almost certainly painted for Lord Elcho; the sitters are unknown, but it is likely that Elcho is depicted.

The interior, when compared to the modest hunting box of *The Melton Breakfast* (painted 1834, see cat.no.21), seems to be of a substantial country house. The composition has fewer figures than the 1834 painting, which suggests an earlier date. Possibly the success of this work encouraged Grant to go to Melton and paint the more complex scene, specifically to be engraved.

CHARLES GEORGE LEWIS 1808–1880
(AFTER SIR FRANCIS GRANT)

21 The Melton Breakfast

Engraving, 50 × 70 cm
Collection of the Duke of Buccleuch and Queensberry KT

The original painting was entered in Grant's sitters' book: '1834 Melton Breakfast painted at Melton, containing various portraits of gentlemen. Bought by Rowland Erington Esq. Engraved. £150.' Also entered is 'June 1835. Copy of Melton Breakfast for W. Gilmour Esq. £105.'

The painting was exhibited at the Royal Academy in 1834, no.245. According to the entry in the RA catalogue, those portrayed are: The Earl of Wilton, Count Matuchevitch, The Lords Rokeby, Kinnaird, Forester and Gardner, Sir Frederick Johnston, Messrs Stanley, Errington and Gilmour, and Lyne Stevens. They are shown in a house in Melton Mowbray known as 'The Old Club'. The room is decorated with a map of Leicestershire and two paintings by John Ferneley on the walls, and a silver racing cup in the corner.

A memorandum of agreement between Messrs Hodgson & Graves and Mr Charles Lewis on engraving a plate of the *Melton Breakfast*, dated 1 September 1838, survives, as does a receipt from Grant of 1 September 1838 to Messrs Graves for copyright of the *Melton Breakfast*.

FREDERICK BROMLEY
(AFTER SIR FRANCIS GRANT)

22 The Meet of His Majesty's Stag Hounds on Ascot Heath (The Ascot Hunt), 1838

Mezzotint, 42 × 22 cm
Collection of the Duke of Buccleuch and
Queensberry KT

The original painting was entered in Grant's sitters' book: '1835 August. His Majesty's Stag Hunt painted for the Earl of Chesterfield, containing various portraits of Gentlemen, Horses and Hounds. Engraved £525.' It was exhibited at the Royal Academy in 1837, no.228.

The Royal Hunt had many illustrious members. According to the RA catalogue, the work portrays (beginning at the left of the picture): 'Henry Freeman, 2nd whip, the Duke of Beaufort, Charles Shakerley Esq, the Count d'Orsay, Colonel Rowley, Lord Adolphus Fitzclarence, George Womberall Esq, Henry Seymour Esq, the Hon James McDonall, Hervey Aston Esq, Mr Davis, Huntsman to HMH, Henry Baring Esq, Sir Horace Seymore KGH, G. Bartlet, 1st whip, G. Megpiece Esq, The Earl of Chesterfield, the Earl of Errol, the Hon George Anson, Thomas Crosby Esq, Sir Andrew Barrard KCB, the Earl of Wilton, Mr Joseph Anderson, Harry King, 3rd whip, going to the deer cart to turn out, the Earl of Chesterfield's coach, Mr Young, his coachman and a groom, the Hon Cecil Forester in the distance; the Lord Frederick Fitzclarence, Thomas Shifney Esq, Thomas Grant Esq, Sir George Seymour GCH, Thomas Learmouth Esq, Robert Nash Esq – Oliver Esq, Richard Vasse Esq, in the distance; J. Bambridge Esq, W. Learmouth Esq, Sir Seymour Blane Bart, Master Lionel Harvey, John Bush Esq, W. Carrol Esq, Lord Alfred Paget, James Fairlie Esq, Paddy and 13 couple of His Majesty's Hounds.'

There exists a letter from Grant to Messrs Graves & Co. of August 1838, acknowledging receipt of £100 for their engraving copyright of the picture.

23 The Shooting Party at Ranton Abbey, 1839

Plate 10
Oil on canvas, 146 × 202cm
Shugborough, The Lichfield Collection
(The National Trust)
Sitters' book: 1837 Nov – Shooting Party at Ranton Abbey for the Earl of Lichfield, containing various portraits and game. Engraved £315 'Party at Ranton Abbey etc'
Exhibited: RA 1841, no.492; V&A 1868

The date in the sitters' book is incorrect, as Queen Victoria, in her diary entry for 21 November 1838, mentioned Viscount Melbourne sitting for this portrait (see p.26). The RA catalogue of 1841 noted that the party included portraits of the Earl of

Sefton, the Earl of Uxbridge, the Earl of Lichfield, Viscount Melbourne, Viscount Anson and Lord Lichfield's keepers.

This painting shows Grant at his closest to David Wilkie.

24 A Foxhound

Chalk on paper, 67 × 51cm
Private Collection

Grant worked up his paintings from detailed chalk drawings. In the case of his hunt pictures, every horse and hound had to be an accurate portrait, as well as the humans depicted. This drawing illustrates the care that Grant spent on his animal portrayals.

25 Henry Sutton, 1846

Chalk on paper, dimensions unknown
Private Collection, England

This study was made for Grant's last important multi-figured hunt picture, *Sir Richard Sutton & his Hounds*, also known as *The Cottesmore Hunt*, which was entered in the sitters' book for 1846. Henry Sutton was one of Richard Sutton's sons. The painting was exhibited at the Royal Academy in 1848 (no.297) and at the *Exposition Universelle* in Paris in 1878 (no.26).

Grant's sensitive study of Henry Sutton treats him as an individual, rather than part of a large group portrait.

26 Queen Victoria Riding Out, 1840

Plate 11
Oil on canvas, 99.1 × 137.5cm
Lent by Her Majesty The Queen
Sitters' book: May 1840 Equestrian portrait of H.M. Queen Victoria, attended by Viscount Melbourne, Marquis of Coningham, Earl of Uxbridge, Honble George Byng and Sir George Quentin – Painted for the Queen. Engraved £367.10s
Exhibited: RA 1840, no.162; VE 1892, no.19

This was Grant's first portrayal of Queen Victoria and she recorded the progress of the commission in some detail in her diary during 1839 (see p.29). She was amused by Lord Melbourne's sitting to Grant '… on that wooden horse without head or tail, looking so funny with his white hat on, and holding the reins which were fastened to the steps.'

In the painting, the figures ride under an imaginary Gothic arch in Windsor Great Park, with a view of Windsor Castle in the background. The Queen rides 'Comus' and looks towards Lord Conyngham, who had been Groom of the Bedchamber and Master of the Robes, and then Lord Chamberlain. Lord Melbourne, Prime Minister, and the young queen's chief advisor and mentor on her accession to the throne in 1837, rides beside

her. The figures under the arch are the Earl of Uxbridge, Lord in Waiting, who later became Lord Chamberlain; his brother-in-law George Byng, later Earl of Strafford, and who was Comptroller of the Household; and Sir George Quentin, equerry of the Crown Stables. There is also a glimpse of Quentin's daughter, Mary, who was the lady rider to the Master of the Horse's department.

27 Mrs Hurt, c.1835

Oil on canvas, 22.9 × 15.2cm
Private Collection
Not in Grant's sitters' book

Mrs Hurt was Francis Grant's sister-in-law, a younger sister of Isabella Norman, Grant's second wife. Cecilia Emily (d.1891) was the fifth daughter of Richard Norman of Melton Mowbray and his wife, Lady Elizabeth Isabella Manners, daughter of the 4th Duke of Rutland. In 1829 Cecilia married Francis Hurt of Alderwasley in Derbyshire. They had nine children, all sons.

28 Harriot Brooke, 1837

Oil on canvas, 76 × 46cm
Private Collection
Not in Grant's sitters' book

Harriot Brooke (1811–1898) was the second daughter of Sir Richard Brooke, 6th Bt. In 1837 she married William Brabazon, a Liberal MP for Co. Dublin, who was styled Lord Brabazon & Lord Ardee until he became Earl of Meath in 1851.

Although the face and hands in this portrait are highly finished, the rest is not, demonstrating that, after establishing a figure's pose, Grant then concentrated on the face and hands. Being unfinished, it is not entered in Grant's sitters' book.

29 Lady Prudhoe (the Duchess of Northumberland), 1843

Plate 27
Oil on canvas, 62.3 × 82.6cm
Collection of the Duke of Northumberland, Alnwick Castle
Sitters' book: 1843 May The Lady Prudhoe
Small full length – G210
Exhibited: RA 1844, no.316

Lady Eleanor Grosvenor (1820–1911), eldest daughter of Richard, 2nd Marquis of Westminster, married Lord Algernon Prudhoe in August 1842. He succeeded as 6th Duke of Northumberland in 1847. Eleanor was known for her kindness and good deeds. The couple had no children.

The guide to the 1844 Royal Academy exhibition described this work as 'an exquisite miniature portrait, a delicious composition, painted with an ease and purity of tone equal to Gainsborough.'

30 Miss Singleton (Lady Rodney), 1844

Plate 28

Oil on canvas, 125.1 × 100cm
Mr and Mrs Edward Harley
Sitters' book: 1844 [April] Miss Singleton (Lady Rodney) Half length £157.10s
Exhibited: RA 1845, no.228; *Exposition Universelle* 1855

Sarah Singleton (1820–1882) was the second daughter of John Singleton and his wife Sarah Moore. In August 1850 she married Robert, Baron Rodney of Rodney Stoke. They had several children.

31 Mrs Hope of Luffness, 1845

Oil on canvas, 89 × 71cm
By kind permission of Luffness Limited
Sitters' book: 1845 [June] Honble Mrs George Hope. Kit Kat £105.

Caroline Georgiana Montagu (d.1891) was the daughter of the 2nd Baron Montagu of Boughton, who was painted by Grant in 1842. He was the third son of the 3rd Duke of Buccleuch.

In 1836 Caroline Georgiana married George William Hope of Luffness.

32 The Ladies Mary and Adeliza Howard, 1847

Plate 32

Oil on canvas, 236 × 144cm (sight)
By permission of His Grace the Duke of Norfolk, Arundel Castle
Sitters' book: 1847 [May] Lady Mary (Lady Foley) & Lady Adeliza Howard, daughters of the Duke & Duchess of Norfolk. Van Dyck full length £420
Exhibited: RA 1848, no.67

Lady Mary Charlotte (1822–1897) and Lady Adeliza Matilda (1829–1904) were daughters of the 13th Duke of Norfolk. They are shown in the park at Arundel, with a view of the castle and the Sussex coast beyond.

Lady Mary was one of the twelve maids of honour at Queen Victoria's wedding in February 1840. She married the 4th Lord Foley in 1849. They lived at Eastbourne and had two sons. She was an accomplished watercolourist.

Lady Adeliza married Lord George Manners, a younger son of the Duke Rutland, in 1855. They lived at Cheveley Park in Cambridgeshire, and had five children.

33 Mrs Chafy in her Bridal Dress, 1853

Plate 43

Oil on canvas, 196 × 111cm
Mr James Swartz
Sitters' book: 1853 [May] Mrs Chafy in her bridal dress. Full length. £315.

Eleanor Constance Collins (1827–1853), daughter of the Revd Charles Collins of Faversham in Kent, married William Westwood Chafy as his second wife in 1853.

This is an early depiction of a woman in similar wedding attire to that seen today – the long white dress and white veil, made fashionable by Queen Victoria. In the nineteenth century, weddings were often small, private affairs, and brides wore dresses that were not necessarily white or in any way lavish.

34 Mrs Naylor, 1857

Plate 40

Oil on canvas, 223.7 × 132.7cm
National Museums Liverpool
Sitters' book: 1857 [May] Mrs Naylor. Full length. £315.

Georgina Edwards married John Naylor in 1846; they had ten children. Although Grant made portraits of several married couples, he painted surprisingly few of them as pendants. This portrait, and that of John Naylor, are of almost identical size and are entered in Grant's sitters' book within a month of each other – May and June 1857. Still elegant, they nevertheless illustrate Grant's broadening of style and increased realism in the second half of the 1850s.

35 Lady Mary Craven, 1861

Plate 46

Oil on canvas, 125 × 99 cm
Collection of the Duke of Northumberland, Alnwick Castle
Sitters' book: 1861 [May] The Lady Mary Craven. Half length.
Exhibited: RA 1862, no.194; RSA 1865, no.689

Lady Mary Craven (1837–1890) was a daughter of the 4th Earl of Hardwicke. In July 1857 she married William George Craven. This portrait remained with Grant's family until 1941 when Sir William Geary (whose father's first wife was Isabella Grant) gave it to Helen, 8th Duchess of Northumberland, granddaughter of Lady Mary Craven.

Broadly painted, this portrait illustrates Grant's increasingly straightforward attitude to his sitters by the beginning of the 1860s.

36 Edward Herbert, 2nd Earl of Powis, 1843

Plate 24

Oil on canvas, 127 × 102cm
Powis Castle, The Powis Collection (The National Trust)
Sitters' book: 1843 [June] Earl Powis. Half length £57.10s.
Exhibited: V&A 1868

Edward Herbert, 2nd Earl of Powis (1785–1848) was MP for Ludlow and then Lord Lieutenant of

Montgomeryshire. He was accidentally shot by one of his sons whilst shooting pheasants in January 1848 and died the following day.

Grant painted Lord Powis's wife two years after this portrait; his sitters' book records the price as £157.10s. This entry suggests that Lord Powis's portrait probably also cost £157.10s., rather than the £57.10s. written in the book.

37 Sketch of Frederick William Hervey, 1st Marquess of Bristol, 1844

Oil on canvas, 75 × 62cm
Ickworth, The Bristol Collection (The National Trust)

Frederick William Hervey (1769–1859), 5th Earl of Bristol, was created 1st Marquess of Bristol and Earl Jermyn in 1826. He was MP for Bury St Edmunds.

Grant's sitters' book records a half-length portrait of the Marquess in December 1844 and, in 1845, a small copy made of this and the 1843 portrait of the Marchioness. The 1845 copies are at Ickworth.

This sketch is presumably the initial idea for the 1844 work, and relates closely to the 1845 copy. It is the only oil sketch on canvas of this type known to have survived.

38 Sir Tatton Sykes, 4th Bt, 1847

Plate 30

Oil on canvas, 274.3 × 183cm
Private Collection
Sitters' book: 1847 June. Sir Tatton Sykes Bart. Equestrian portrait the size of life. £420.
Exhibited: RA 1848, no.441; RA 1856/7, no.370

A plaque on the frame states that 'this portrait was presented to him' (Sir Tatton) 'as a mark of esteem and regard by about 600 of his friends and neighbours'.

Sir Tatton Sykes (1772–1863) was a well-known and popular Yorkshire landowner. A rider, boxer, Master of Foxhounds and MP for forty odd years, he successfully bred sheep (amongst which he is shown here) and racehorses from the early nineteenth century. Sir Tatton is mounted on his favourite hack, Revenge, having ridden the horse to London for this portrait. He greatly improved his estates, reclaiming a large area of the Yorkshire wolds, and treated his tenants in exemplary fashion, although he was less kind to his own family.

39 Walter Little Gilmour, 1850

Oil on canvas, dimensions unknown
Property of a Gentleman
Sitters' book: 1850 Jan W. Little Gilmour Esq. Head size. £105.

Walter Little Gilmour (1807–1887) was one of Grant's closest friends throughout his life and Grant painted him on numerous occasions, with and without horses. Gilmour also appears in both *The Melton Breakfast* of 1834 and *The Melton Hunt Going to Draw Ramshead Covert* of 1839.

Here he is shown with a view of the River Tweed in the background.

40 William Henry Cavendish-Bentinck-Scott, 4th Duke of Portland, 1852

Plate 35
Oil on canvas, 195.6 × 143.5cm
Private Collection
Not in Grant's sitters' book
Exhibited: RA 1853, no.376

The Duke of Portland (1768–1854) was one of the most prominent agriculturists of his day. He was also a far-sighted businessman. Earlier an MP, he was Lord Lieutenant of Middlesex for nearly fifty years. This portrait, showing the Duke in his eighty-fourth year, was presented to the sitter by nearly 800 of his tenants.

The Duke's two great loves were the study of shipbuilding and horses. He won the Derby with Tiresias in 1819.

41 John Naylor, 1857

Plate 41
Oil on canvas, 225.6 × 132.7cm
National Museums Liverpool
Sitters' book: 1857 [June]. John Naylor Esq. Full length. £315.

John Naylor (1813–1889) was painted as a pendant to the picture of his wife of the same year (cat.no.34). Both portraits were presented to the sitters by their tenants and tradesmen.

Naylor was a great-nephew of Thomas Leyland, a Liverpool banker. He was given the estate of Leighton, near Welshpool by his uncle Christopher Leyland and rebuilt the house in the Gothic style. He collected British paintings and owned several works by J.M.W. Turner as well as David Wilkie's *Bathsheba*.

42 Isaac Newton Wallop, 5th Earl of Portsmouth, 1859

Oil on canvas, 225 × 132 cm
By kind permission of the Earl of Portsmouth and the Trustees of the Portsmouth Settled Estates
Sitters' book: 1859 [June] The Earl of Portsmouth. Full length. £315.

Grant had already painted the Countess of Portsmouth in 1855. Lord Portsmouth (1825–1891) is painted on a fractionally larger canvas than his wife, although his portrait is ostensibly a pendant to hers.

A Liberal in politics, Lord Portsmouth helped Gladstone in drafting the Irish Land Bill of 1870. Here he is portrayed very much as the country landowner in the middle of his estates.

43 The Ladies Susan and Constance Murray, 1841

Plate 22
Oil on panel, 28 × 23cm
Collection of the Earl of Mansfield, Scone Palace

The children were daughters of the 6th Earl of Dunmore and his wife, Lady Catherine Herbert. Lady Susan (b.1837) married the Earl of Southesk in 1860 and Lady Constance (b.1838) married the 1st Baron Elphinstone in 1864.

This is a sketch for a larger painting entered in Grant's sitters' book: '1841 April Ladies Susan & Constance Murray, children of the Earl of Dunmore. £210.'

44 Lord Charles Scott, 1842

Plate 21
Oil on canvas, 128 × 102.5cm
Collection of the Duke of Buccleuch and Queensberry KT
Sitters' book: 1842 [June] Lord Charles Scott, son of the Duke of Buccleuch. Half length. £517 10s.
Exhibited: RA 1843, no.334

Lord Charles Thomas Montagu Douglas Scott (1839–1911) was the third son of the 5th Duke of Buccleuch and his wife Charlotte Ann. He entered the Royal Navy in 1853 and served in the Russian War in the Baltic in 1854, the Black Sea in 1855, the China War in 1857, where he was mentioned in dispatches, the Indian Mutiny 1857–8, and Formosa. He was promoted to Captain in 1872 and became an Admiral in 1888.

45 Sketch of Lord Charles Scott, 1842

Oil on canvas, 26 × 21cm
Collection of the Duke of Buccleuch and Queensberry KT

Grant seems to have made small preparatory oil sketches for all his portraits. They were compositional aids, more precise details being worked up with chalk drawings.

46 Unknown Boy, probably The Hon. Charles Talbot, 1843

Oil on canvas, 39 × 29cm
Private Collection

This painting corresponds with an entry in Grant's sitters' book: '1843 [June] Honble C. Talbot. Small with pony.' The Hon. Charles Talbot (b.1830) was educated at Eton and Merton College, Oxford. He became Viscount Ingestre in 1849 and Earl of Shrewsbury in 1868. Here, he appears to be about thirteen years old. Grant had used an identical composition, although on a much larger scale, for *The Earl of Zetland with a horse* of 1841.

47 Master James Fraser on his Pony, 1844

Plate 23
Oil on canvas, 129 × 152.5cm
Yale Center for British Art, Paul Mellon Collection
Sitters' book: 1844 April. Master Fraser on horseback. Small full length. £210.
Exhibited: RA 1845, no.436

James Keith Fraser (b.1832) was in his twelfth year when this picture was painted. His father, Sir James Fraser of Ledclune, was one of the Duke of Wellington's staff officers at Waterloo. James Keith Fraser went on to pursue a distinguished military career, becoming a Lieutenant General and was ultimately appointed Inspector General of Cavalry in Great Britain and Ireland.

48 The Two Sisters (The Dawson-Damer Children), 1841

Oil on canvas, 74.9 × 61.6cm
Private Collection
Sitters' book: 1841 [Oct] The two youngest children of the Honble Colonel Dawson-Damer – Head size
Exhibited: RA 1843, no.307

The girls were daughters of George Lionel Dawson, later Dawson-Damer, and Mary, daughter of Lord Hugh Seymour. Five daughters are recorded, the two youngest probably being Evelyn Mary Stuart (d.1899) who married Captain Francis Sutton in 1855, and Constance (d.1925), who married Sir John Leslie in 1856.

49 Sir Walter Scott, 1832

Plate 5
Oil on canvas, 76.2 × 64cm
Scottish National Portrait Gallery, Edinburgh
Sitters' book: Feb 1832. Sir Walter Scott painted at Abbotsford in his study, whilst dictating 'Count Robert of Paris', with his greyhounds, painted for Lady Ruthven. Small Full length. Engraved. £50
Exhibited: RSA 1832, no.219

Sir Walter Scott (1771–1832), poet and novelist, knew Francis Grant from the latter's early boyhood, and was hugely helpful to him. Scott wrote about Grant in his *Journal* and recorded the sittings for this painting.

This small scale work illustrates the tight handling and meticulous detail of Grant's early pictures.

50 Sketch of James Thomas Brudenell, 7th Earl of Cardigan, 1841

Plate 25
Oil on canvas, 40 × 36.5cm
National Portrait Gallery, London

Lord Cardigan (1797–1868) pursued a now infamous military career. In 1826 he joined the 8th Hussars and was Lieutenant Colonel of the 11th Hussars 1836–54. Remarkably handsome, but quarrelsome and unpopular, he reputedly spent £10,000 per annum on his regiment.

In 1854 he served in the Crimea under the command of his brother-in-law, the Earl of Lucan. Lord Lucan gave the mistaken command for Lord Cardigan to charge some 3,600 Russians with his brigade of 600 cavalry. The Russian guns left nearly half of Cardigan's men and horses dead. The episode was immortalised in Tennyson's poem 'The Charge of the Light Brigade'. Cardigan himself was wounded and received the four clasp Crimean medal for his gallantry there.

This is a sketch for the equestrian portrait of 1841, recorded in Grant's sitters' book as 'Life-size in regiments. £420'. The large painting was admired by Queen Victoria when she saw it exhibited at the Royal Academy in 1842, but it was criticised by Benjamin Haydon. The sketch has a drama and vitality lacking in the finished work.

51 Sir James Brooke, 1847

Plate 29
Oil on canvas, 142.8 × 111.1cm
National Portrait Gallery, London
Sitters' book: Oct 1847. James Brook [sic] Esq. Rajah of Sarawak and Governor of Lebhan. Half length, presented to him.
Exhibited: VE 1892, no.82

Sir James Brooke (1803–1868), a curious and charismatic figure, ran away from school aged sixteen and became a cadet in the Bengal Infantry. When his father died in 1831 he inherited £30,000, bought a 142-ton schooner and sailed for Borneo. He arrived in Sarawak, a small area on the northwest coast of Borneo, then subject to the Malay Sultan of Brunei. An excellent horseman and shot, he suppressed a rebellion in Sarawak in 1840 and was invited to assume government there in 1841.

He finally left Sarawak in 1863, being succeeded as Rajah by his nephew Charles Brooke. Although unproven charges of cruelty and illegal conduct had been brought against him, he was regarded as a great benefactor. When he left Sarawak its extent had increased to 28,000 square miles with a flourishing population of 250,000. Trade had expanded, agriculture was greatly improved and piracy and head-hunting had been stopped.

Brooke was painted during a visit to England in 1847. Grant's nephew, Charles Grant, eldest son of John Grant, was one of Brooke's aides.

52 James Rannie Swinton, 1850

Plate 4
Oil on canvas, 61.3 × 45.8cm
Private Collection
Sitters' book: 1850 [August] James R. Swinton Esq. Small half length. £105.
Exhibited: RA 1851, no.224; RSA 1852, no.378

James Rannie Swinton (1816–1888) was born near Duns in Berwickshire. He studied at the Trustees' Academy with William Allan and John Watson Gordon. He entered the RA Schools in London in 1840. After spending three years in Italy and Spain, he returned to London where he set up a successful portrait practice.

53 Benjamin Disraeli, 1851

Plate 33
Oil on canvas, 77.5 × 64.1cm
Hughenden Manor, The Disraeli Collection (The National Trust)
Sitters' book: 1851 [May] B. D'Israeli Esq. Head size.
Exhibited: RA 1852, no.54; RSA 1852, no.232

Benjamin Disraeli (1804–1881) had a political career lasting almost fifty years. First elected a Conservative MP in 1837, he was three times Chancellor of the Exchequer and Prime Minister in 1868 and 1874–80.

He began his career as a lawyer but gave up due to ill health. He went abroad and started writing. His first novel, *Vivian Grey*, was published in 1826. *Coningsby* of 1844 and *Sybil* of 1845, are two of the earliest British political novels, in which Disraeli sets out Tory principles of England as a country united by Church and Crown. He became a close friend of Queen Victoria and was created Earl of Beaconsfield in 1876. A brilliant statesman, a political opponent described him as 'a first rate courtier, a second rate novelist, and a third rate politician'.

54 Sir Edwin Landseer, 1852

Plate 39
Oil on canvas, 114.2 × 89.2cm
National Portrait Gallery, London
Sitters' book: [April] 1852 Sir Edwin Landseer Bart. Half length for W. Wells Esq. £100.
Exhibited: RA 1855, no.387

Sir Edwin Henry Landseer (1802–1873) was the youngest son of the artist John Landseer. A precocious talent, he rapidly established himself as the most popular and expensive painter of his era. As well as producing superb animal paintings, he also designed the lions for the Nelson monument in Trafalgar Square.

Grant and Landseer were close friends. In this portrait, Landseer painted the dog. Various oil sketches of Landseer by Grant survive, including examples in the National Portrait Gallery, Royal Academy and Russell Coates Art Gallery in Bournemouth.

The painting was commissioned by William Wells of Redleaf. He was a close friend of Landseer and had a large collection of his work.

55 Lord John Russell, 1853

Plate 44
Oil on canvas, 201.3 × 111.9cm
National Portrait Gallery, London
Sitters' book: [May] 1853 The Lord John Russell. Full length.
Exhibited: RA 1854, no.193; *Exposition Universelle*, 1855

Lord John Russell (1792–1878) was a younger son of the 6th Duke of Bedford. A Whig MP from 1813, he was a strenuous advocator of reform. A member of the cabinet from 1832, he was Prime Minister 1846–52 and 1865–66, and one of the most influential statesmen of his day. He was created Earl Russell in 1861.

In Grant's portrait, Russell is holding a paper inscribed 'Reform Bill 1854'. The leather bound book on the table is inscribed 'State/papers/1853'.

56 Sketch of Thomas Babington Macaulay, 1853

Plate 34
Oil on canvas, 29.8 × 25.4cm
National Portrait Gallery, London
Sitters' book: [May] 1877. Lord Macaulay. A sketch sold to Sir William Maxwell Stirling [sic] for National Portrait Gallery. The original sketch. £105.

Macaulay (1800–1859), son of the philanthropist, Zachary Macaulay, became a barrister in 1826, and an MP in 1830. He was a member of the supreme council of India 1834–8 and Secretary at War 1839–41. He was given a peerage in 1857. After his political career was over, he became a writer, best known for his *History of England* and his narrative poem *Lays of Ancient Rome*.

57 Sketch of Sir Hugh Gough, 1st Viscount Gough, 1853

Pen and ink on paper, 17.8 × 13.6cm
National Portrait Gallery, London

Lord Gough (1779–1869) became an adjutant at the age of fifteen. He was present at the capture of the Cape of Good Hope in 1795. He then served in the West Indies and the Peninsula War, 1808–13. He became a Major General in 1830 and served in the China War 1841–2. He was Commander in Chief, India, in 1843, and Commander of the British Forces during the two Sikh Wars. He was created Viscount in 1849 and Field Marshall in 1862.

Gough sat to Grant in 1853; this is probably a sketch made from memory after Grant's full-length portrait of Gough at Woolwich. An earlier study shows Gough's right arm in a lower position.

58 General Sir James Hope Grant, 1853

Plate 30

Oil on canvas, 222.4 × 132.1cm
Scottish National Portrait Gallery, Edinburgh
Exhibited: RA 1854, no.138; RSA 1860, no.403

Hope is wearing the dress uniform of a Lieutenant-Colonel of the 9th Lancers. The portrait was presented to the Scottish National Portrait Gallery by Lady Hope Grant in 1892.

59 Sketch of Edward Stanley, 14th Earl of Derby, 1858

Oil on canvas, 127 × 102cm
Private Collection

Lord Derby (1799–1869) was one of the key political figures of his age and the leader of the Tory party after Robert Peel's fall in 1846. He was Prime Minister in 1852, 1858–9 and 1866–8.

A superb orator, he was known as 'Scorpion Stanley'. Lord Melbourne wrote of him to Queen Victoria in 1839: 'Stanley everyone knows to be a man of great abilities, but of much indiscretion, and he is extremely unpopular.'

The half-length sketch is a preparatory work for the full-length painted in 1858 and still at Knowsley.

60 Sir Colin Campbell, Lord Clyde, c.1860

Plate 49

Pen, ink and watercolour on paper, 25.4 × 12.7cm
National Portrait Gallery, London

Lord Clyde (1792–1863), the son of a Glasgow joiner, served in the Peninsula, 1810–13, the West Indies, 1819–26, China, 1842–6, India, 1846–53 and the Crimea, 1854–5. He was Commander in Chief in India 1857–69 where he suppressed the Indian mutiny. He was created a peer in 1858 and a Field Marshall in 1866.

According to an inscription on the mount, the drawing was executed at Lord Hardinge's home, South Park, from Grant's recollection of the full-length painting of 1860. Drawing his own portraits from memory was quite common practice for Grant. Grant presented Lord Hardinge, a great friend, with the sketch.

61 Henry John Temple, 3rd Viscount Palmerston, 1862

Oil on canvas, 127 × 102cm
Harrow School, Middlesex
Sitters' book: [April] 1862 Viscount Palmerston for Harrow Library. Half length. £210.
Exhibited: RA 1874, no.115 (This was probably the version now in the Government Art Collection, which also seems to have been painted in 1862.)

Lord Palmerston (1784–1865), an old Harrovian, was an MP from 1807, Secretary at War 1809–28, Foreign Secretary 1830–41 and 1846–51, Home Secretary 1853–5 and Prime Minister 1855–8 and 1859–65. A supporter of parliamentary reform, his vigorous policy of intervention made him one of the most powerful men on the European political stage.

Queen Victoria said that she never liked him. Lord Malmesbury wrote that his unpunctuality 'was the grievance and terror of the whole Corps Diplomatique'.

62 Sketch of Orlando Bridgeman, 3rd Earl of Bradford, 1866

Oil on board, 64 × 29cm
Private Collection

Lord Bradford (1819–1898) was MP for South Shropshire 1842–65, Lord Lieutenant of Shropshire 1875–96, Lord Chamberlain 1866–8, and Master of the Horse 1874–80 and 1885–6.

This is the sketch for the portrait entered in Grant's sitters' book for 1866.

Grant emphasises Lord Bradford's height and elegance in a way that anticipates the works of Whistler and Sargent.

63 Edward Nugent, 6th Earl of Milltown, 1875

Plate 53

Oil on canvas, 240 × 148cm
National Gallery of Ireland, Dublin
Sitters' book: The Earl of Meltown [*sic*]. Full length. £420.
Exhibited: RA 1876, no.162

Lord Milltown (1835–1890), was educated at Trinity College, Dublin, before being called to the Bar at the Inner Temple, London, in 1862, where he practised as a special pleader. He inherited from his elder brother, Joseph Henry, who died in 1870. He was Lord Lieutenant of Co. Wicklow and a Privy Councillor.

Here he is seen out shooting, with his family home, Russborough, in the distance.

64 A Royal Procession, c.1877

Plate 56

Oil on canvas, 101.6 × 127cm
Private Collection, courtesy of Simon C. Dickinson Ltd
Not in Grant's sitters' book
Exhibited: RA 1878, no.451

This painting was exhibited in 1878 under the title 'A Royal Group in a Highland Deer Forest' with the following note: 'The scene is reminiscent of the forest of Invercauld'. Invercauld, on the River Dee near Braemar, was the family home of Amelia Farquharson, Grant's first wife. The stags are all 'Royals', that is, bearing antlers with twelve points. Until the late twentieth century the painting remained with Grant's family, where it was known as 'A Royal Procession'.

65 Charlotte Anne, Duchess of Buccleuch and her Son, 1838

Plate 20

Pen and ink on paper, 27.5 × 24.5cm
Inscribed: 28 Oct 1838
Collection of the Duke of Buccleuch and Queensberry KT

This was drawn at Drumlanrig where Grant, on the same day, also made an extremely beautiful sketch of the Marchioness of Lothian.

This drawing is of the type that Grant made from observation to amuse himself and his companions – rapid and often penetrating.

66 Sir Francis Grant's Sitters' Book

Bound volume, 19.2 × 12cm
Inscribed: List of works by Sir Francis Grant PRA
Copy of list of pictures by my father, Sir Francis
Grant, from a manuscript book kept by my mother,
Lady Grant. Dec 1898
[Miss] E.C. Grant (Indexed and annotated by John
Steegman in 1938)
National Portrait Gallery, London

This book, compiled by Elizabeth, Grant's favourite daughter, from records kept by Isabella Norman, his second wife, includes about eighty percent of Grant's total production. Family portraits and pictures painted as gifts were not usually entered. Some prices are missing.

67 Album compiled by Amelia (Emily) Grant

Bound volume, 26 × 21cm
Private Collection
On the first page is written in Grant's handwriting:
'To the Memory of a Wife' [a poem from
Edmeston's *Sacred Lyrics*]

The first drawing in the book is inscribed 'Drawn by F Grant and pasted in by Emily Grant.' A further drawing has written below it in Grant's writing, 'This and all the following drawings were collected by Emily Grant with the intention of pasting them in this book which she kept on purpose for her husband's drawings, who after her death pasted them in as was her intention.'

As well as being a prime source for Grant's early drawings and etchings, the book also contains copious writings by Grant, copied from diverse sources, which show how deeply affected Grant was by Amelia's death after childbirth in November 1827.

68 Album compiled by Mrs Markham (Daisy Grant)

Bound volume, 20.3 × 10.1cm
Inscribed on the cover: WTM [and] Becca Hall
Inside the binding there is a black and white printed bookplate 'In the collection of Anne Emily Sophia Markham 1879'
Private Collection

The album contains drawings by several hands, including many amusing ones by Grant. In the nineteenth century, it was fashionable to collect drawings to form an album.

In 1829 Grant wrote to his second wife's grandmother, the Duchess of Rutland: 'I shall hope to send your Grace some sketches before I leave England – sufficiently delicate in their execution to be placed in your album.'

69 Travelling Sketchbook

12 × 16cm
Inscribed inside cover:
'2 academy of painting J V Eyk [*sic*]
3 Jerusalem church
(Hospital of St John etc)'
Private Collection

This was the sketchbook used by Grant when he travelled in the Low Countries with the then Lord Granby, later 6th Duke of Rutland, in the autumn of 1844. The pencil drawings record places and paintings that must have particularly struck Grant, as well as Grant and Lord Granby sketching together.

70 Catalogue of the Pictures, Ancient and Modern, in Kinfauns Castle, 1833

Kinfauns Press, 1833
Leather bound, 38.1 × 26.7cm
Private Collection

Lord Gray, who built Kinfauns Castle, had his own private printing press at Kinfauns, Perthshire.

Francis Grant wrote the catalogue, although it is signed only with his initials, F.G. As well as showing what a splendid collection Lord Gray had acquired, the text reveals Grant's views, at this early stage of his career, on the different old masters and British painters of the eighteenth and early nineteenth centuries.